A HISTORY OF
Mormon Landmarks in
UTAH

A HISTORY OF
Mormon Landmarks
in
UTAH
Monuments of Faith

Andy Weeks

Published by The History Press
Charleston, SC
www.historypress.net

Copyright © 2015 by Andy Weeks
All rights reserved

First published 2015

Manufactured in the United States

ISBN 978.1.62619.976.7

Library of Congress Control Number: 2015950781

Notice: The information in this book is true and complete to the best of our knowledge. It is offered without guarantee on the part of the author or The History Press. The author and The History Press disclaim all liability in connection with the use of this book.

All rights reserved. No part of this book may be reproduced or transmitted in any form whatsoever without prior written permission from the publisher except in the case of brief quotations embodied in critical articles and reviews.

For Brayden—
who, by his example, has taught me so much about life and the gospel.
I'm proud of you, Son. Thank you for making a difference.
I love you!

CONTENTS

Acknowledgements	9
Introduction	11

PART 1. UTAH
"Top of the Mountains"	17

PART 2. MORMONS
The Roots of Mormonism	29
Old Scripture Revealed Anew	37
Brigham Young and Succession	43

PART 3. MONUMENTS
"This Is the Place"	49
Temple Square and Nearby Monuments	63
A Historic Look at Temples	83
Temples as Spiritual Monuments	96
Temple Topper: Angel Moroni	107
Where Prophets and Paupers Rest	110
Pioneer Memorial Park	116
Of Faith and a Fort	125
Tabernacles and Other Historic Buildings	127
All Is Well with Church Welfare	135
News of the Day, Yesterday and Today	138

Contents

In the Land of Tragedy	142
History on Display	149
Researching and Preserving the Past	154
Appendix	159
Notes	161
Bibliography	167
Index	171
About the Author	176

ACKNOWLEDGEMENTS

Writing books is a love of my life, but it also is hard work—sometimes tremendously so when many other things sit on my plate awaiting my attention, including deadlines from work and other sources. Most of the books I've written so far have happened while working at busy newspapers as a reporter and/or editor—another love of my life. Each book has had its challenges, but so have they had their blessings. The same is true of this one. I wrote much of this book while working away from home as the editor of two community newspapers, during a time when my son was finishing up high school and preparing for a church mission. My family schedule was in flux. I was on the road a lot, and when I came home I sometimes felt I couldn't give anymore to the project. Thankfully, my awesome editor, Artie Crisp, extended my deadline. For this and his help securing many of the photos for the book, I extend my deepest appreciation.

I also appreciate those at Arcadia Publishing and The History Press, including Katie Parry in marketing, who has helped promote my other HP titles, and those who proofread and designed the manuscript. Elizabeth Farry once again did an excellent job streamlining the production process. You do great work, each of you, and I appreciate how you all rally as a team to help us authors.

As always, I appreciate my wife, Heidi, who encouraged and motivated me during this hectic time, reminding me that even with an extended deadline it'd be here before I knew it. She was right, as she most always is. It's been fun to work on a faith-oriented book as our son prepares to serve a church

Acknowledgements

mission in the Philippines. As always, he has been an example of faith to me during the writing process. I've dedicated this book to the people of his mission that he'll be serving and teaching in the islands, as well as to those whom I served and taught—and who taught me—on my mission stateside. I hope they'll have the chance to visit Utah, if they haven't already done so, and some of its historic Mormon landmarks.

Most of the information about the monuments has been gleaned over many years being a member of the LDS Church, researching its history and visiting many of the historic sites. The church's official website, LDS.org, has been a helpful source, as have other online sources and printed material. I wish I had more time and means to have secured firsthand information about the sites, but living outside the state during much of its writing meant I often had to turn to secondary sources. Obviously, the research, views and opinions expressed herein are my own, and I recognize better than anyone the book's limitations. More research would have been helpful if time and circumstance allowed. But as a busy professional, I tried to do the best I could with what I had to work with. This is not a definitive volume on the historic markers in Utah or of LDS church history. In essence, the stories contained herein are but snippets of the larger historical record and aim to draw more interest about the sites. Nor is the book in any way associated with or approved by The Church of Jesus Christ of Latter-day Saints. As a fallible person with very human traits, I have tried to make the manuscript as factual and faith-promoting as I could with my own understanding, research and perspective. If there are errors in the history presented here, they are unintentional. My goal in writing the book has been to promote faith, understanding and respect for the LDS Church and its expansive and interesting past and to start readers on a journey to further explore the iconic landmarks of Mormonism. There are many ways a book such as this could be written. This is but my simple offering to a church and history I extremely adore.

As always, I appreciate the authors, journalists and historians who, through their own writings online and off, have helped me in the research and writing of this book. As an author and journalist, I know the work we do sometimes is thankless. But I thank you, tremendously so.

INTRODUCTION

When Brigham Young led a band of Latter-day Saints to the Great Salt Lake Valley in 1847, he looked over the expansive and fertile country and, perhaps feeling affirmation in his soul, proclaimed, "This is the right place. Drive on." He knew that the Mormons, having fled their homes in the Midwest because of persecution and mob violence, had found the place "Far away in the West"[1] where they could worship God according to the dictates of their own conscience.

This beautiful and rugged place, later legislated and named Utah, became the forty-fifth state of the Union in 1896. Today it boasts a population of nearly three million people, varied outdoor attractions, fine art museums and many historical landmarks that add color and perspective to a people and faith that formed a unique culture in the arid West.

The book is divided into three parts—Utah, Mormons and Monuments—with many chapters between its covers. Part 1 gives a brief review of the state, not a complete history, while Part 2 briefly tells the beginning of the Mormon faith. Part 3 is the core of the book, which highlights a number of Latter-day Saint historical markers in the Beehive State. These include temples, bronze statues, granite markers, a fort and old homesteads, cemeteries and grave sites, chapels and other buildings, as well as other historical icons. It is in essence a simple book about some—*not all*—of the historical markers important to the LDS faith in Utah. Not all of them are managed by the church, though many of them are, and the brief summaries or historical tidbits presented here are aimed to spark more interest in the monuments instead of giving a complete history.

Introduction

Caring for the monuments is a task that is never complete, but the church and other organizations involved take great pride in preserving their historical significance. I tried to include in the manuscript as many of the monuments as I could while also focusing on basic LDS tenets to give background and context; thus, there is a lengthy chapter on the history of temples as I understand it from the teachings of scripture and general authorities. I did this primarily for readers who may not be as familiar with the history of the church and its reasoning behind some of its basic tenets, such as why Latter-day Saints believe the Book of Mormon is comparable to the Holy Bible or why they build temples. Having an understanding of the faith helps readers better understand the importance of the monuments the pioneers left behind and those the church has built in more modern times. Also, when writing of the early temples the church built in Utah, I share spiritual or other interesting experiences that allegedly happened in them rather than focusing on the historical context of the buildings. This book may have special interest to those visiting the Beehive State who'd like to learn more about some of its historical landmarks. You don't have to be Mormon to enjoy the colorful history that makes up Utah.

I've enjoyed researching and learning about the monuments, visiting many of them over the years, and I applaud the church and other organizations involved for what they have done and continue to do to preserve, protect and promote these magnificent sites that, each in its own way, tell us something of our pioneer past.

It has been a pleasure for me to revisit my own faith as I've considered and researched the topics included herein. The Latter-day Saint religion is dynamic, diverse and, with hierarchal teachings that leave little room for discussion, can for some people also be demanding. For the joyful faithful, it is an exuberant religion that brings surety in an uncertain world, peace in a time of chaos, faith in a world of fear and perspective in a world full of differing voices.

It was faith, determination and skill that allowed the Mormons to build their great Utah monuments—and it is faith that allows them to keep building them today not only in Utah but in many parts of the globe, in the form of new chapels, stake centers, temples, institutes, missions, farms and much more.

The historic markers are but an emblem to the real monuments of the Latter-day Saints: God, Family, Country and Self-Respect. These are the virtues and beliefs, the faith and dedication that caused the pioneers to act and accomplish. They are the same things that cause men and women of

Introduction

goodwill everywhere to tread new paths and be pioneers in their own time and place. As a modern-day apostle, Elder Neal A. Maxwell said, "Though we have rightly applauded our ancestors for their spiritual achievements (and do not and must not discount them now), those of us who prevail today will have done no small thing. The special spirits who have been reserved to live in this time of challenges and who overcome will one day be praised for their stamina by those who pulled handcarts."

PART 1
UTAH

I prophesied that the Saints would continue to suffer much affliction and would be driven to the Rocky Mountains, many would apostatize, others would be put to death by our persecutors or lose their lives in consequence of exposure or disease, and some of you will live to go and assist in making settlements and build cities and see the Saints become a mighty people in the midst of the Rocky Mountains.[2]
—Joseph Smith

"TOP OF THE MOUNTAINS"

Utah, forty-fifth state of the Union, was the eye candy of the Latter-day Saints long before they arrived in the Salt Lake Valley in the summer of 1847. After continued persecution by naysayers and apostates, the Mormon prophet Joseph Smith saw in a vision the Saints' removal from the humid Midwest to the arid West. It'd be the Rocky Mountains to which the Mormon faithful would flee, and with them their determination to remain steadfast and build a monumental religion under the banner of heaven.

Though Smith saw in vision the great trek of his people, he would never join the Saints in their New Zion because of a mob's bullets that struck him down on June 27, 1844, in Carthage, Illinois, just two years before the body of the church moved west. It would be Smith's successor, Brigham Young, who would direct the Latter-day Saints to the Rocky Mountains during the great modern-day exodus of 1846–47, unparalleled since Old Testament times. Like that Old Testament patriarch and prophet Moses, Brigham Young later would be called a "modern Moses."

In hindsight, it seemed that the Latter-day Saints—a deeply religious people whose doctrinal organization is in line with the Bible—were indeed destined to inhabit the land that in 1896 would be called Utah. When Brigham Young and a band of Mormons first made their entrance into the Salt Lake Valley that summer day in 1847, they not only beheld the widespread basin with its rivers and streams and many agricultural opportunities, but they also viewed, far off in the distance, a great inland lake

A History of Mormon Landmarks in Utah

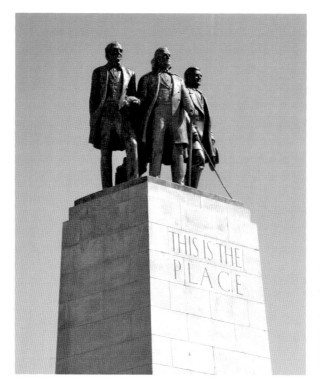

A bronze sculpture of Brigham Young, flanked by other early church brethren, stands tall as it depicts the Mormon leader overlooking the Salt Lake Valley in 1847. Young and his party entered the valley from Emigration Canyon, where This Is the Place Heritage Park memorializes this and later years in early church history. *Photo by Andy Weeks.*

that exceeded the ocean in salt content. There are no oceanic tides that flow here, though the Saints soon learned the Great Salt Lake had similarities to another ancient body of water: the Dead Sea. Like that great inland lake in Israel, which receives its confluence from the Jordan River in which Jesus was baptized, Utah's salty lake is fed by its own Jordan River. Interestingly, the topography of both lands have other similarities.

Another biblical tie to Utah is its name. The Latter-day Saints, nicknamed the Mormons because of their belief in the Book of Mormon, an ancient scriptural text that affirms biblical truths, called their home Deseret, a name taken from their sacred book that means honeybee and symbolizes industry. But others, years later when statehood was eminent, petitioned for the name Utah, which in the Ute vernacular and as highlighted in the LDS movie *The Mountain of the Lord* means "Top of the Mountains." In a show of goodwill, Utah was nicknamed the Beehive State.

The Mormons proved to be industrious indeed, for here they built businesses, welfare centers, wide streets, thriving communities, churches and a magnificent temple that Mormons believe, in part, fulfills a prophecy by the Old Testament prophet Isaiah: "And it shall come to pass in the last days, that the mountain of

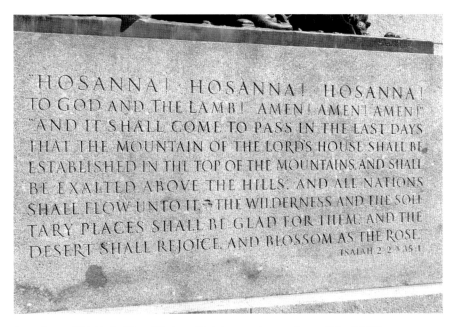

A marker at This Is the Place Heritage Park honors the prophecy of the Old Testament prophet Isaiah that Latter-day Saints believe has at least partially been fulfilled by the Mormons in Utah. *Photo by Andy Weeks.*

the Lord's house shall be established in the top of the mountains, and shall be exalted above the hills; and all nations shall flow unto it."[3] The naming of Utah had, as far as the Mormons were concerned, fulfilled biblical prophecy.

For many people the words "Mormon" and "Utah" are synonymous terms because of the high number of Latter-day Saints who call the Beehive State their home; but that need not be the case nowadays. Utah is a state that over the years has become more diverse in both its population and its religions. By 2010 population estimates, nearly three million people, both Mormon and non-Mormon alike, called Utah their home. It's true, however, that you cannot understand Utah history without knowing something of the Mormons because of the religion's influence in the state's settlement, growth and development. Much of Utah's population today resides along the Wasatch Front, in urban sprawl that stretches from Ogden to Provo's Utah Valley. The mix of big cities, small townships, farming communities, open space and outdoor venues attract a number of new residents every year, both the religious and secular.

In 2002, the Beehive State, encompassing 84,876 square miles, attracted the world's attention when it played host to the winter Olympics and

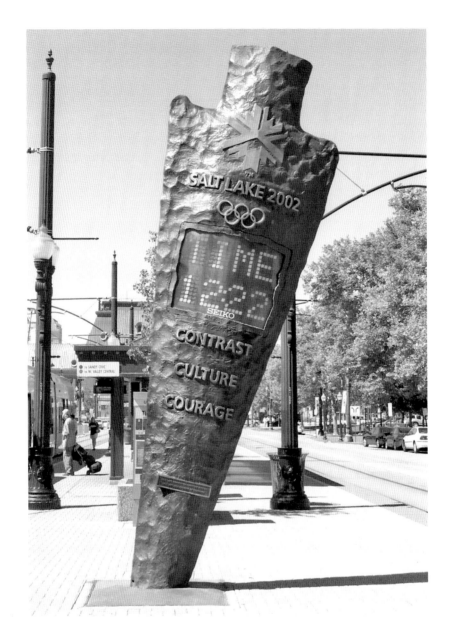

The official 2002 Winter Olympics Countdown Clock in downtown Salt Lake City. Salt Lake City played host to the 2002 Winter Olympics. The clock sits on the northern end of the Arena UTA TRAX station. The clock was unveiled on May 15, 2001, and counted down days until the start of the 2002 games. When this TRAX station was built, numerous Native American arrowheads were discovered, and the clock was designed as an arrowhead to recognize this. *Creative Commons CC0 1.0 Universal Public Domain Dedication.*

Paralympics. And in early 2009, Utah was voted one of the country's best places to live. "Here residents reported a high level of satisfaction in several areas, including work environment, emotional health and their local communities," reads a March 2009 article in *Forbes* magazine. It is estimated that the state will add another two million people by the year 2035.

THE GREAT SALT LAKE

Something that makes Utah unique among the states is its great inland sea. The Great Salt Lake, a majestic body of water that according to 2015 estimates is about seventy-five miles long and thirty-five miles wide, is the largest natural lake west of the Mississippi River. As with most lakes, a slight rise in water level expands its surface measurably, thus size estimates may vary from year to year. First measured in 1849, the lake's level has varied by some twenty feet, according to Utah.com, causing the shoreline to shift in some places as much as fifteen feet.

The lake, a remnant of massive Lake Bonneville that covered much of the present-day western United States some twelve thousand to twenty-three thousand years ago, is said to contain as much as 4.9 billion tons of dissolved

When Brigham Young beheld the Salt Lake Valley in 1847, he couldn't help but notice the area's great inland sea in the distance. The Great Salt Lake is a natural marvel and today a popular place for sailing. *Photo by Cliff Johnson, Creative Commons Attribution-ShareAlike 2.0.*

salt content. "As the lake rises, its salinity drops because the same amount of salt is dissolved in more water," reads information from Mineral Resources International. Its website, mineralresourcesint.com, explains why the lake remains so salty: "As water flows over or moves beneath the Earth's surface, it dissolves minerals from the soils and rocks. The streams that originate in the Wasatch Range and other nearby mountains all flow into the Great Salt Lake, bringing in water with varying percentages of dissolved minerals. Since the lake has no outlet, all of these minerals remain in the lake."

The lake, despite its high salinity—or perhaps because of it—has held a sense of mystery even before the pioneers came to the valley. Explorers and fur trappers encountered the great lake and were baffled by its mystique. Waterfowl like it, and it is a favorite place for seagulls, pelicans and herons. In its center sits Antelope Island, which is even more mysterious if you have not visited the island and seen its wildlife.

The lake is indeed a marvel of the natural world, and in modern times it has become a favorite place for sailors, who, with their watercraft in tow, come here to recreate on the water. Visit the lake during summer evenings and you'll likely see a number of sailboats drifting on the placid surface.

Wasatch Mountains

Towering toward the skies over Utah is the Wasatch Mountain Range, the western range of the Rocky Mountains that stretch from the Bear River at the state's northern edge to Mount Nebo near Nephi in central Utah. In most places peaks reach some 9,000 to 10,000 feet high, while the highest point is Mount Nebo at 11,877 feet.

When the Mormons arrived, first having to traverse through the mountain passes, they found the range a necessary part of their new environment. It provided water from its many streams and rivers, game and timber from its forests and granite and other ores from its deep deposits.

The mountains called Wasatch also served as a wall that protected the Saints and their valley from the hindrances of the outside world, at least to a point. Others came here, but they first had to tackle the massive Rockies. Just ask the pioneers; it wasn't an easy task.

As far as we know, the mountains were first encountered by Fathers Francisco Atanasio Dominguez and Silvestre Velez de Escalante in 1776 near present-day Spanish Fork. Later, other explorers, hunters and fur

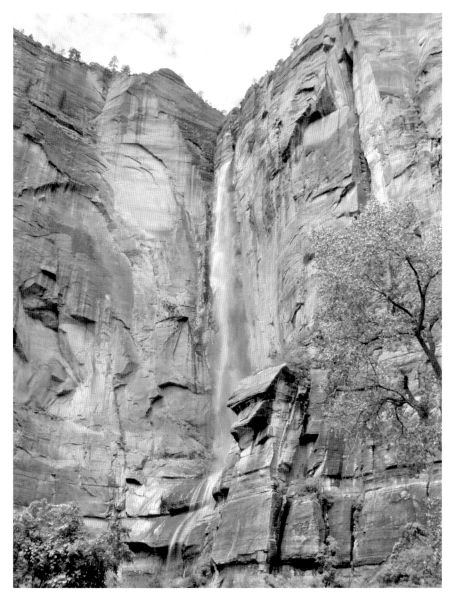

Snowmelt forms an ephemeral waterfall at the Temple of Sinawava. *National Park Service photo by Rebecca Alfafara.*

trappers viewed the mountains, some of them traversing through them, marking their history by the trails they blazed. For a much longer period, however, it was the Ute Indians and other tribes who knew the mountain range best, having lived in its shadow for millennia.

On the opposite side of the Salt Lake Valley, in its western portions, lies another range called Oquirrh Mountains, where with its copper flat-tops sit the world's largest open-pit copper mines. The Oquirrhs are scenic mountains with their own forests and rivers and wildlife, and they divide the Salt Lake Valley and Tooele Valley, the latter being west of the range.

It is the larger Wasatch Mountains, however, that people connect with the Beehive State. The mountains are an iconic symbol of the Salt Lake Valley and Utah and are a destination for recreationists of all types, from the occasional summer angler to the avid winter snowbird. Utah wouldn't be Utah without its mountains, and Wasatch is the greatest of them all.

Canyon Lands

Utah has a variety of offerings in the way of geology, geography and even paleontology. The most popular in this latter category is near Vernal in northeastern Utah. Dinosaur National Monument is home to many hundreds of fossils. These ancient bones come from stegosaurus, camarasaurus, diplodocus and dilophosaurus, among others. You can even see some of their footprints imprinted into rock beds, such as near Red Fleet Reservoir. Dinosaurland is shared with Colorado, and it is a pleasant experience to visit the sites these areas have to offer and envision Utah as it may have been when dinosaurs walked the landscape, which, in geological and evolutionary terms, was much different than it is today.

Other natural wonders that exist in the state include artistic canyon lands such as Bryce Canyon or Zion National Park, where Mother Nature has provided an abundance of iconic rocks and stalagmites that for a long time have sparked wonder in visitors young and old. These are naturally made

Zion National Park's Towers of the Virgin in winter. *National Park Service photo by Christopher Gezon.*

Utah

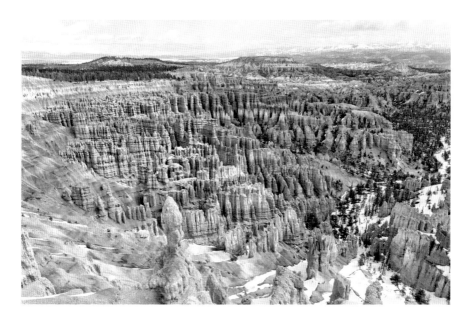

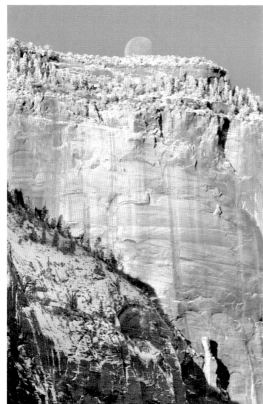

Above: Amphitheater at Bryce Canyon National Park. *Photo by Jean-Christophe Benoist.*

Left: The moon sets behind the West Temple on a cold winter morning in Zion National Park. *National Park Service photo by Christopher Gezon.*

monuments that, like our pioneer markers, may evoke faith in those who consider the rocks' creation. These parks are some of the natural gems of the Beehive State, attracting visitors from all over the country.

Utah has it all—farmlands, marshes, prairie lands, waterscapes and varied landscapes—and you never have to travel far to enjoy it. In the midst of it all, there usually are mountains either in the fore- or background.

Desert Oasis

Visit the above-named national parks and you'll find something else about Utah: it is very much a desert state. Here the climate is dry, with temperatures reaching in the high nineties and, on occasion, the low one hundred during summer. When the snow flies in winter, the dryness of the region makes it so you can bundle up and usually stay warm, unlike places in the Midwest where the cold seems to go right through a person because of the humidity.

And don't think desert means just brown sand and dusty roads. While there are those things here, the state is decorated with green fields, beautiful prairies and plenty of streams and rivers. Places such as Moab and St. George offer red-rock desert scenery but also have plenty in the way of outdoor recreation—and not all of it involves sand.

Enjoy Utah

No matter if you live in the Beehive State or are visiting for the first time, it is a marvelous place to be. Brigham Young was right: Utah is the right place…for all kinds of people and all types of activities. Of course, you're reading this book for a reason, so let's move on to the Mormons and their monuments. I hope you'll enjoy (or do enjoy) Utah and visiting the monuments of faith described in this book.

Chances are you've already visited some of them, but I hope you'll return and look on them in a new light. Remembering the past encourages us to face the future, even when it seems challenging. "There is something about reviewing the lessons of the past to prepare us to face the challenges of the future," Elder L. Tom Perry said. "What a glorious legacy of faith, courage and ingenuity those noble early Mormon pioneers have left for us to build upon. My admiration for them deepens the longer I live." May our admiration also deepen as we study the pioneer past.

PART 2
MORMONS

*I don't blame anyone for not believing my history.
If I had not experienced what I have, I would not have believed it myself.*[4]
—Joseph Smith

THE ROOTS OF MORMONISM

The Church of Jesus Christ of Latter-day Saints—its members commonly known as Mormons, Latter-day Saints or simply LDS—claim it is not a manmade church but a restoration of the primitive gospel taught by Jesus Christ in time's meridian. The church's very organization is biblical in nature, being led by apostles and prophets, which the general membership sustain as seers and revelators, but affirm that the true head of the church is Jesus Christ, whom Latter-day Saints worship as their Savior and Redeemer, the Promised Messiah and Son of God.

The church believes in modern revelation—just one principle that sets it apart from the other churches of the day. Unlike most of Christendom, who believe revelation ceased with the printing of the Holy Bible and say all that God ever wanted humankind to know about him is contained in that volume of holy scripture, the Mormons believe that God, "the same yesterday, and to day, and for ever,"[5] continues to speak with mortal man just as he did in the biblical record. They believe that God answers prayers—a form of revelation in itself—and that in a quiet grove in upstate New York in the spring of 1820 he answered the sincere prayer of a young man that would change the way millions viewed Christianity.

That young man was Joseph Smith, and to understand the Mormons and why their landmarks in Utah and elsewhere are worthy of discussion, a person should have an understanding of Smith, his claim to revelation and authority and some of his basic teachings and testimony. In this section a brief perspective is given of Joseph Smith, whom millions revere

as a latter-day prophet not unlike Old Testament prophets such as Adam or Moses or Isaiah.

President John Taylor, a successor of the prophetic mantle, wrote a tribute to Joseph that now is contained in the church's Doctrine and Covenants, claiming:

> *Joseph Smith, the Prophet and Seer of the Lord, has done more, save Jesus only, for the salvation of men in this world, than any other man that ever lived in it. In the short space of twenty years, he has brought forth the Book of Mormon, which he translated by the gift and power of God, and has been the means of publishing it on two continents; has sent the fulness of the everlasting gospel, which it contained, to the four quarters of the earth; has brought forth the revelations and commandments which compose this book of Doctrine and Covenants, and many other wise documents and instructions for the benefit of the children of men; gathered many thousands of the Latter-day Saints, founded a great city* [Nauvoo], *and left a fame and name that cannot be slain. He lived great, and he died great in the eyes of God and his people; and like most of the Lord's anointed in ancient times, has sealed his mission and his works with his own blood; and so has his brother Hyrum. In life they were not divided, and in death they were not separated.*[6]

"Follow me," Jesus instructed certain disciples along the shores of Galilee. They were fishermen by trade, and they dropped their nets and followed him, relying on his promises and blessings. "I will make you fishers of men," he instructed them, promising that with faith and authority they would accomplish mighty miracles.[7]

In all, Christ called twelve men to follow him as his closest and most revered associates. These men were not only disciples, a word meaning "to follow," but specially appointed witnesses of Christ and his work; they were to be apostles. To these men he gave power, called priesthood, and directed them to lead the church he then was establishing among them, with a "foundation of apostles and prophets, Jesus Christ himself being the chief corner stone."[8] They were set apart for the divine mandate by the laying on of hands by the Great High Priest himself.

With this authority his apostles could heal the sick, make blind eyes see, deaf ears hear, lame legs walk and unclean spirits flee. They could move mountains by this same power, if their faith and the will of God so allotted them. The priesthood they held allowed them to baptize for the remission

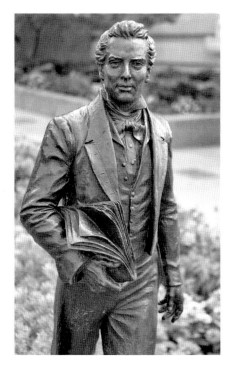

Joseph Smith, founder of the Mormon church, claimed to have been directed by heavenly angels in bringing back the ancient gospel of Christ that was lost for centuries during a period know as the great apostasy. Among the things he brought forth was the Book of Mormon, an ancient record of the early Americas and their religious life and controversy, which Smith translated into modern English. *Photo by Andy Weeks.*

of sins and lay hands upon those newly baptized for the reception of the Holy Ghost—in other words, to baptize with water and of the Spirit. It allowed them to administer the Lord's sacrament, officiate in temple ordinances and proclaim the gospel with power and authority.

The apostles did many marvelous works after Christ's resurrection, and by the priesthood authority given them they were able to ordain others to various callings within the church. Without the authority of the priesthood, such sacraments and ordinations were not acknowledged by God. Such a scenario would be much like a mailman in our day issuing a speeding ticket; he or she has no authority to do so and the ticket then would be null and void. It is the same with religious matters; a blessing given or ordinance performed is only valid—acknowledged by God—if done with the proper authority.

Many came after Christ and his apostles, proclaiming they had authority to build a church, proclaim the gospel and baptize. Such chaos started when one by one the apostles whom Christ had appointed and duly set apart for their sacred callings were persecuted and killed. The Jewish leaders of the day had ransacked the faith and sent Jesus to the cross; likewise, they persecuted his followers and each of the apostles, but John, who was banished to the Isle of Patmos where he received his famous Revelation, fell to a martyr's death. With their demise came the death of the apostleship, and the church, sustained by these twelve men and the priesthood authority they held, fell into a world of gospel distortion and apostasy.

That's the time, in essence, when many churches began to spring up, each proclaiming to be the true church. But nowhere in the land was the official

church Christ had established, because no authorized servant had the keys of authority to direct the church or carry the gospel forward. The true ministers were dead or gone. Each church that came about at this time and afterward had parts of the true faith, but not the complete package. They did not have the true priesthood as administered by the apostles.

Prophets, of whom the Lord said he would do nothing without first revealing his will to them,[9] had foreseen such a time when the world would be without the fullness of the gospel. "Behold, the days come, saith the Lord God, that I will send a famine in the land, not a famine of bread, nor a thirst for water, but of hearing the words of the Lord: And they shall wander from sea to sea, and from the north even to the east, they shall run to and fro to seek the word of the Lord, and shall not find it."[10]

The dark ages of a world without gospel light, however, would not last forever. A light—the light of the true and complete gospel as taught by Christ—was prophesied to once more be upon the earth before Jesus would return. Peter, the chief apostle in New Testament times, proclaimed that "times of refreshing" would come before Christ's second advent, "times of restitution of all things, which God hath spoken by the mouth of all his holy prophets since the world began."[11]

Webster describes *restitution* as "the act of returning something that was lost or stolen to its owner," "an act of restoring or a condition of being restored," and *restoration* as "the act or process of returning something to its original condition by repairing it, cleaning it, etc.," "the act of bringing something back that existed before" or "the act of returning something that was stolen or taken." What Peter was saying was that the gospel, foretold to fall into a state of apostasy—which Webster describes as "abandonment of a previous loyalty"—would one day be restored to its original and complete condition.

Man had tried to bring a semblance of biblical organization back to the church, men like John Wycliffe and Martin Luther. These men, often called the Reformers, aimed for just that—a reformation of the church. Under a clear conscience, they tried to align church teachings with the Bible. In some cases they did; in others they failed. These men were noble, their work notable, but there was one flaw in their ambition: they had no authority. And they knew it. They could not bring back that which was lost only because their hearts told them to do so; they vied for reformation, but they could not complete restoration without divine aid. If the gospel in its complete rendition—err, its authority—was nowhere on the earth, men with the purest intentions could do little in bringing about a restorative act. It would take heaven-sent messengers to do that.

Mormons

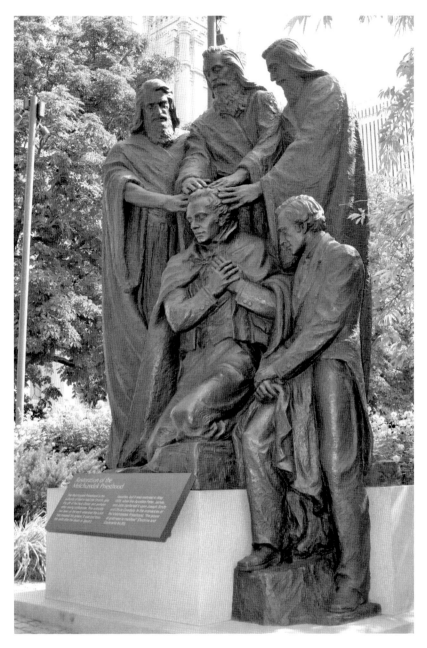

According to Mormon doctrine, Joseph Smith received priesthood authority from the ancient apostles Peter, James and John, who appeared to the young prophet as physical angels in 1829. Smith claimed they laid their hands on his head and bestowed on him the same authority these ancient apostles held under Jesus Christ. Priesthood is the authority to act in the name of God. This bronze depiction is on the grounds of the Salt Lake Temple. *Photo by Andy Weeks.*

Enter Joseph Smith, who in a quiet grove in the springtime of 1820 sought God through prayer and found the answer of a lifetime. The glad tiding of the gospel is that God—who once spoke to Adam in the Garden of Eden, Abraham under a starry night sky and Moses in a burning bush—spoke to Joseph Smith in more modern times, answering the petition of his heart.

Joseph grew up in a home of religious tolerance and faith. His father, although inclined against organized religion, nonetheless encouraged Bible study and prayer. Joseph's mother leaned toward the Methodist faith and often joined them in worship, as did young Joseph for a time. And yet seeing the "contest of religion," as he describes in his history, one church vying for members, another doing the same and all the churches in commotion saying they were the right faith, caused Joseph, as it should have other penitent souls, to wonder which of all the many churches truly was acknowledged by God as his church and kingdom. Was there a true church? he wondered. Or were they all wrong together? If there was a right one, which one was it and which should he join? He assumed there must be a true church on the earth, for why would a perfect and caring God leave people in darkness?

Young Joseph, according to religion professor and author Truman G. Madsen, would often look up into the night sky and marvel at the symmetry and beauty and order of the heavens. Then his mind would wander to earthly matters and all he saw was disorder and confusion among the churches. The manmade confusion, he surmised correctly, was out of character for an orderly God.

The contest, at least for Joseph, came to an end in the spring of 1820. During the course of his Bible study, Joseph, only about fourteen years of age at the time and encouraged by a passage from James that said to take questions to God in prayer and he would answer liberally,[12] decided he must get his own answer to the question "which church is right?" He felt as if his very soul depended on it. One morning he decided to do as James directed and retired to a grove of trees near his family's home in Palmyra, New York, where he could be alone without distraction or interruption to pour out his heart to his Maker. In Joseph's own words, he explained:

> *After I had retired to the place where I had previously designed to go, having looked around me, and finding myself alone, I kneeled down and began to offer up the desires of my heart to God. I had scarcely done so, when immediately I was seized upon by some power which entirely overcame me, and had such an astonishing influence over me as to bind my tongue so that*

I could not speak. Thick darkness gathered around me, and it seemed to me for a time as if I were doomed to sudden destruction.

But, exerting all my powers to call upon God to deliver me out of the power of this enemy which had seized upon me, and at the very moment when I was ready to sink into despair and abandon myself to destruction—not to an imaginary ruin, but to the power of some actual being from the unseen world, who had such marvelous power as I had never before felt in any being—just at this moment of great alarm, I saw a pillar of light exactly over my head, above the brightness of the sun, which descended gradually until it fell upon me.

It no sooner appeared than I found myself delivered from the enemy which held me bound. When the light rested upon me I saw two Personages, whose brightness and glory defy all description, standing above me in the air. One of them spake unto me, calling me by name and said, pointing to the other—"This is My Beloved Son. Hear Him!"[13]

James was right, young Joseph learned. God does hear and answer prayers. A person could inquire of God—even a young man such as he—and the Lord liberally would answer. Joseph, who had come to the grove for a specific purpose, pressed on:

My object in going to inquire of the Lord was to know which of all the sects was right, that I might know which to join. No sooner, therefore, did I get possession of myself, so as to be able to speak, than I asked the Personages who stood above me in the light, which of all the sects was right (for at this time it had never entered into my heart that all were wrong)—and which I should join.

I was answered that I must join none of them, for they were all wrong; and the Personage who addressed me said that all their creeds were an abomination in his sight; that those professors were all corrupt; that: "they draw near to me with their lips, but their hearts are far from me, they teach for doctrines the commandments of men, having a form of godliness, but they deny the power thereof."

He again forbade me to join with any of them; and many other things did he say unto me, which I cannot write at this time. When I came to myself again, I found myself lying on my back, looking up into heaven. When the light had departed, I had no strength; but soon recovering in some degree, I went home.[14]

Joseph received the answer to his inquiry: none of the existing churches, all manmade, were right in the sight of God. Sure they taught good principles, even proclaiming that there was a living God and Savior, but they had no authority from heaven to proclaim the gospel, let alone baptize for the remission of sins. Churches of the day claimed a priesthood, but it was defunct because it had not come from God but from man and his degrees. Also, some churches proclaimed a belief in the trinity—that God, Son and Holy Spirit were one in form and fashion. Joseph learned otherwise. Through his experience in the grove, he learned that God and Christ are two separate and distinct persons, not one in being but one in purpose. He also learned something of the nature of evil, having been attacked by an unholy presence before the glorious encounter. We assume it was Satan trying to thwart the young man in his godly quest for heaven's knowledge.

Young Joseph learned many other truths during the heavenly experience, among which that he was to join none of the then existing churches. Instead, he was told that he would, at a later time if he proved worthy, be an instrument in the Lord's hands in bringing about that which had been lost for centuries during the long night of apostasy—the restitution of the ancient order as prophesied by Peter and other notable apostles and prophets in the biblical past.

The First Vision, as Joseph's heavenly encounter is commonly called, was the first of many for the emerging prophet. Now that he had found out sublime truths, his next task was to translate ancient scripture into modern language.

OLD SCRIPTURE REVEALED ANEW

One of the first things Joseph Smith did as a prophet, even before officially organizing the church with six members on April 6, 1830, was translate an ancient book of scripture for modern readers. The story of the Book of Mormon—heralded to the world as Another Testament of Jesus Christ, not as a volume to replace the Holy Bible but to complement it—is one of the true miracles of the restored church.

It began on the night of September 21, 1823, while seventeen-year-old Joseph, before retiring to bed, petitioned God in earnest prayer. Soon, his room began to be lighted by an unearthly glow that grew in intensity until his whole room was filled with brilliant light. In its midst was a figure who revealed himself as Moroni, a prophet who lived in the Americas some 1,400 years in the past.

During his mortal sojourn, Moroni was caretaker of the metallic plates that had been passed down by others of the time and that told the story of the rise and fall of ancient civilizations that lived on the American continent. The plates' chronology began around 600 BC—with additions going as far back as the Tower of Babel—until Moroni's time in about AD 421 when sometime before his death he buried the plates in the earth and received a promise by the Lord that at a future day they would be revealed anew. Their coming forth in the latter days would be as if the dead were speaking from the dust heralding their message and warning to modern readers.[15]

Now on a New York evening while Joseph lay wide-eyed at the heavenly figure, he was being told the time had come to bring the plates to light.

And Joseph was to do it. It was the beginning of his prophetic duties and in fulfillment of what the Lord told him three years earlier in the sacred grove: that at a then future time Joseph would have a great work to accomplish. Recovering and translating the Book of Mormon was but the beginning.

"He called me by name, and said unto me that he was a messenger sent from the presence of God to me, and that his name was Moroni; that God had a work for me to do; and that my name should be had for good and evil among all nations, kindreds, and tongues, or that it should be both good and evil spoken of among all people," Joseph wrote of that September night visitor.

> *He said there was a book deposited, written upon gold plates, giving an account of the former inhabitants of this continent, and the source from whence they sprang. He also said that the fulness of the everlasting Gospel was contained in it, as delivered by the Savior to the ancient inhabitants; Also, that there were two stones in silver bows—and these stones, fastened to a breastplate, constituted what is called the Urim and Thummim—deposited with the plates; and the possession and use of these stones were what constituted 'seers' in ancient or former times; and that God had prepared them for the purpose of translating the book.*[16]

During the course of the visit, Joseph was told when he obtained the plates that he must not show them or the instruments to any person except those to whom the Lord commanded:

> *While he was conversing with me about the plates, the vision was opened to my mind that I could see the place where the plates were deposited, and that so clearly and distinctly that I knew the place again when I visited it. After this communication, I saw the light in the room begin to gather immediately around the person of him who had been speaking to me, and it continued to do so until the room was again left dark, except just around him; when, instantly I saw, as it were, a conduit open right up into heaven, and he ascended till he entirely disappeared, and the room was left as it had been before this heavenly light had made its appearance.*[17]

To Joseph's surprise, Moroni visited the maturing prophet two other times during the night, repeating what he had told Joseph previously and adding caution and instruction. We mortals are fickle and need reassuring. We also learn by repetition. It is not unlikely that the repeated visits were to impress

on Joseph's mind the seriousness of the work he was called to do and its grave responsibility. Joseph continues the narrative:

> *He commenced, and again related the very same things which he had done at his first visit, without the least variation; which having done, he informed me of great judgments which were coming upon the earth, with great desolations by famine, sword, and pestilence; and that these grievous judgments would come on the earth in this generation. Having related these things, he again ascended as he had done before.*
>
> *By this time, so deep were the impressions made on my mind, that sleep had fled from my eyes, and I lay overwhelmed in astonishment at what I had both seen and heard. But what was my surprise when again I beheld the same messenger at my bedside, and heard him rehearse or repeat over again to me the same things as before; and added a caution to me, telling me that Satan would try to tempt me (in consequence of the indigent circumstances of my father's family), to get the plates for the purpose of getting rich. This he forbade me, saying that I must have no other object in view in getting the plates but to glorify God, and must not be influenced by any other motive than that of building his kingdom; otherwise I could not get them.*
>
> *After this third visit, he again ascended into heaven as before, and I was again left to ponder on the strangeness of what I had just experienced; when almost immediately after the heavenly messenger had ascended from me for the third time, the cock crowed, and I found that day was approaching, so that our interviews must have occupied the whole of that night.*[18]

When Joseph went to work on the farm that morning, his body was exhausted from staying up all night and his father told him to go home to rest. Joseph obeyed, looking forward to a morning nap, but heaven had other plans for him. The nap would have to wait.

While crossing the fence out of the field, the young man fainted from exhaustion. When he began to emerge from sleep, he heard his name being called. He opened his eyes and saw Moroni standing above him in all his angelic majesty. He didn't instruct him to slumber but to the place Joseph had been shown in vision where the plates were buried. Before he journeyed to the location, however, he was commanded by the angel to go back to his father, Joseph Smith Sr., and relate his experiences of the previous night. Smith believed his son, telling young Joseph to do as the angel instructed. Joseph immediately went forth and found the hidden location—a rock

protruding from the earth on a nearby hill now called Cumorah. What happened next is best described in the prophet's own words:

> *Having removed the earth, I obtained a lever, which I got fixed under the edge of the stone, and with a little exertion raised it up. I looked in, and there indeed did I behold the plates, the Urim and Thummim, and the breastplate, as stated by the messenger. The box in which they lay was formed by laying stones together in some kind of cement. In the bottom of the box were laid two stones crossways of the box, and on these stones lay the plates and the other things with them.*
>
> *I made an attempt to take them out, but was forbidden by the messenger, and was again informed that the time for bringing them forth had not yet arrived, neither would it, until four years from that time; but he told me that I should come to that place precisely in one year from that time, and that he would there meet with me, and that I should continue to do so until the time should come for obtaining the plates.*
>
> *Accordingly, as I had been commanded, I went at the end of each year, and at each time I found the same messenger there, and received instruction and intelligence from him at each of our interviews, respecting what the Lord was going to do, and how and in what manner his kingdom was to be conducted in the last days.*[19]

Eventually the time came for Joseph to receive the plates, which he did on a September night in 1827. He then translated the engravings into the English language and published it to the world in 1830 as the Book of Mormon.

Why the Book of Mormon Is Important

What is the purpose of another book of scripture when we already have the Bible? Does the Bible need complementing, or can it stand on its own merits? Is the Book of Mormon for Latter-day Saints only?

Let's start with the last question first. No, the Book of Mormon is not for Latter-day Saints alone; it is for all people for this purpose: "to the convincing of the Jew and Gentile that Jesus is the Christ, the Eternal God, manifesting himself unto all nations."[20] The Holy Bible is a marvelous book that for centuries has provided hope, comfort and direction to millions of people. But the Bible in itself is not a complete book of all of God's dealings

with humankind, nor is it a perfect book. By its very nature it is a "book of books," meaning a volume containing many books, thus leaving the door open that there might be additional scripture just as sacred. The Bible also contains discrepancies and omissions caused by the frailty—and in some instances the direct violation—of translators. It often contradicts itself.

The Book of Mormon was translated into the English language once by Joseph Smith and contains a more complete view of the doctrines of Christ. The Book of Mormon, for instance, gives the reader a better understanding of faith, repentance, baptism, the gift of the Holy Ghost, the atonement of Christ, the character of God, importance of service and missionary work, the ministering of angels, the role of prophets, life after death, the spirit world, judgment and resurrection and the second coming of the Messiah, among many more principles and doctrines.

"I told the brethren that the Book of Mormon was the most correct of any book on earth," the Prophet Joseph Smith said, "and the keystone of our religion, and a man would get nearer to God by abiding by its precepts, than any other book."[21]

The wonderful thing about the Book of Mormon is that persons, each and every one, may know for themselves if its message and claims are true. They may know its truthfulness by studying the book with sincere intent to understand and then taking their questions to God in prayer. Moroni, that same angelic being that visited young Joseph on a September night and delivered the golden plates to him some four years later, wrote on the plates before his mortal passing, giving a promise to all then-future readers of the book:

> *Behold, I would exhort you that when ye shall read these things, if it be wisdom in God that ye should read them, that ye would remember how merciful the Lord hath been unto the children of men, from the creation of Adam even down until the time that ye shall receive these things, and ponder it in your hearts.*
>
> *And when ye shall receive these things, I would exhort you that ye would ask God, the Eternal Father, in the name of Christ, if these things are not true; and if ye shall ask with a sincere heart, with real intent, having faith in Christ, he will manifest the truth of it unto you, by the power of the Holy Ghost.*
>
> *And by the power of the Holy Ghost ye may know the truth of all things.*[22]

What kind of feelings may come as an answer? Paul described the feelings of the Spirit as "love, joy, peace, longsuffering, gentleness, goodness, faith, Meekness, temperance…"[23] Similar feelings, thoughts or impressions, even a burning in the bosom or warm feeling in the chest may be an answer, or the calming feeling of contentment and joy.

On a more direct level pertaining to the establishment of Mormon doctrine in the latter days, two great and important episodes occurred early in the restoration, setting a foundation for yet more that was to come: God and Jesus had personally appeared to young Joseph, revealing the true nature of their beings—that they are two separate and distinct personages in the very fashion of man; and the Book of Mormon, an ancient book of scripture, was brought to light that reveals and further clarifies doctrines lost from the Bible and complements that holy book with the message that Jesus is the Christ, the Savior of the world. In a world as secular as ours, we don't have to look far to see why an additional testament of the Living Messiah is needed.

BRIGHAM YOUNG AND SUCCESSION

After Joseph Smith was killed on June 27, 1844—shot in cold blood while imprisoned on false charges at Carthage Jail—the persecutors thought it'd be the end of Mormonism. Joseph was dead. No longer would the Saints be able to look on their prophet-leader, hear his voice or see his smiling face; they would not ever again receive instruction from him, not in person. And yet if anything, his death made the cause he established even stronger. Why? Because it was not his cause at all, but God's.

Unlike the New Testament apostles, who once taken from the earth caused the church's downfall because of lost authority, the restoration church was destined to endure beyond its first prophet. Early on, Joseph considered the restoration church prophecy fulfilled, likening it to Daniel's vision of the latter days when "the God of heaven [would] set up a kingdom, which shall never be destroyed: and the kingdom shall not be left to other people, but it shall break in pieces and consume all these kingdoms, and it shall stand for ever."[24]

The priesthood given to Joseph Smith on the banks of the Susquehanna River by Peter, James and John sometime in about June 1829, not quite a year before he officially organized the church, was here to stay. During the course of the restoration, Joseph called men to the apostleship just as Jesus had done, gave them authority and organized them into a body of twelve. When Joseph's spirit passed beyond the veil, the mantle of prophetic authority, the keys of revelation, fell upon the Quorum of Twelve Apostles. Brigham Young was the quorum president. Eventually, Young was appointed

A History of Mormon Landmarks in Utah

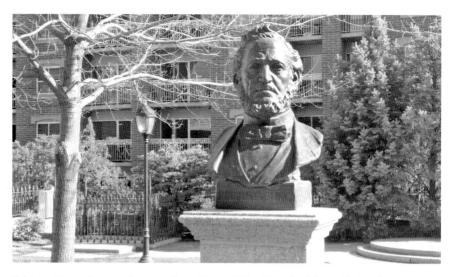

Brigham Young became the second president of The Church of Jesus Christ of Latter-day Saints after Smith was killed in 1844. Mormons consider Smith a martyr for the cause he established, and Young, no less vibrant in his testimony of the restored gospel, led the church into its next chapter in Utah. He is here honored with a bronze bust at Pioneer Memorial Park in Salt Lake City. *Photo by Andrew Weeks.*

and ordained Smith's successor and the second president of The Church of Jesus Christ of Latter-day Saints. In a line of authority, the priesthood was passed from Smith to the Twelve, with each prophet succeeding in Young's fashion the prophet before, to the present day and receiving the same keys of authority that Smith received under the hands of Peter, James and John, who in New Testament times received it at the hands of the Great High Priest himself, Jesus Christ.

In this fashion, the church is led by a prophet today. Once he passes, another with authority, taken from the Twelve, will be appointed in his place. Latter-day Saints are assured that God will continue to speak to his chosen witnesses and through them guide his latter-day church, now and in the future. The mandate is to follow the brethren and you will not be led astray.

Nothing—"not anything, not anyone, not any influence—will keep this Church from fulfilling its mission and realizing its destiny set from before the foundation of the world. Ours is that fail-safe, inexorable, indestructible dispensation of the *fullness* of the gospel," said Elder Jeffrey R. Holland, speaking to religious educators on February 6, 2015.

> *The momentum that began in a grove of trees in upstate New York two centuries ago will continue to roll forth, unabated and undeniable—Daniel's stone cut out of the mountain without hands (Daniel 2:45). That scriptural kingdom will be triumphant, and it will prevail. Unlike every other era before us, this dispensation will not experience an institutional apostasy; it will not see a loss of priesthood keys; it will not suffer a cessation of revelation from the voice of Almighty God. Individuals will apostatize, they may turn a deaf ear to heaven, but never again will the dispensation collectively do so. What a secure thought that is! What a day in which to live! What a way to cut through fear or faintheartedness.*[25]

Elder Holland was echoing what the Prophet Joseph taught in his day:

> *Our missionaries are going forth to different nations, and in Germany, Palestine, New Holland, Australia, the East Indies, and other places, the Standard of Truth has been erected; no unhallowed hand can stop the work from progressing; persecutions may rage, mobs may combine, armies may assemble, calumny may defame, but the truth of God will go forth boldly, nobly, and independent, till it has penetrated every continent, visited every clime, swept every country, and sounded in every ear; till the purposes of God shall be accomplished, and the Great Jehovah shall say the work is done.*[26]

As for Joseph's first successor, Brigham Young, he is important to this book because of his part in leading the Saints to Utah, establishing church headquarters in Salt Lake City, and in many ways developing the state. Nicknamed the "Lion of the Lord" and often referred to as a "modern Moses," Young was a fiery gentleman with a passion for the Mormon gospel. Because of his sometimes bold personality, he has sometimes been misunderstood.

"If Brigham Young is not the most misunderstood individual on the lists of the 100 greatest and most influential Americans," write Chad M. Orton and William W. Slaughter, "he likely has been the most maligned. While he is more favorably viewed now than during his lifetime—as evidenced by the fact that he is included in these lists—in many regards he remains as enigmatic and vilified in death as he was in life. Few people have had so much written about them while remaining so little understood."[27]

No matter how you view Brother Brigham, you have to respect him for what he did for the cause, including his influence in establishing many monuments and markers that still stand today in the Beehive State.

Young was a great man, an entrepreneur and true leader, one possessed with deep convictions and an abiding love for the Prophet Joseph Smith and the God of Heaven, whom both he and Joseph claimed had set the latter-day work in motion. There would be no Utah without Brigham and his fervent and undying determination to build the kingdom of God in the shadow of the Rocky Mountains, fulfilling a vision foreseen years earlier by Mormonism's first prophet. Without Young, there would be no pioneer monuments in Utah.

PART 3
MONUMENTS

We must be sure that the legacy of faith received from the pioneers who came before us is never lost. Let their heroic lives touch our hearts, and especially the hearts of our youth, so the fire of true testimony and unwavering love for the Lord and His Church will blaze brightly within each one of us as it did in our faithful pioneers.[28]
–Elder M. Russell Ballard

"THIS IS THE PLACE"

"This is the right place"—Brigham Young's now famous quote after viewing the Salt Lake Valley for the first time in 1847—almost seems like a cliché. There is, however, nothing common about This Is the Place Heritage Park, where visitors step back in time to see how the pioneers lived. The park, operated by This Is the Place Heritage Foundation, memorializes a period in Utah and the West that no longer exists. Fittingly, it is located at Emigration Canyon in the foothills of Salt Lake City where Brigham Young and other Latter-day Saint pioneers entered the valley.

Brothers Joseph and Brigham

While Brigham Young lay on his deathbed in 1877, thirty years after arriving in Great Salt Lake Valley, his last words were "JOSEPH! JOSEPH! JOSEPH!"—attesting to the deep bond that he and the prophet Joseph Smith shared.[29] It is only fitting that a bronze statue of Brigham and Joseph welcome visitors to This Is the Place Heritage Park.

The statue is placed near the visitor center and gift shop, not far from the parking lot as people come into the park. Smith is overlooking Young's shoulder, both gazing into the distance, while the junior apostle holds a scroll that reads, "Great Basin and Route to the Rockies."

A History of Mormon Landmarks in Utah

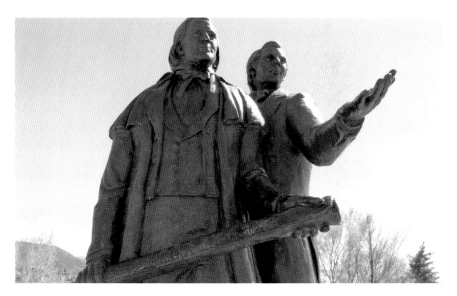

Joseph Smith, years before the Latter-day Saints started their trek west, saw in vision years before his death that the Saints would relocate to the Rocky Mountains. Here, he said, they would grow into a great and numerous people. This statue of Smith, directing Brigham Young, is depicted at This Is the Place Heritage Park in Salt Lake City. *Photo by Andy Weeks.*

The statue symbolizes a prophecy Joseph Smith made in 1842, two years before his death: "I prophesied that the Saints would continue to suffer much affliction and would be driven to the Rocky Mountains," he said. "Many would apostatize, others would be put to death by our persecutors or lose their lives in consequence of exposure or disease, and some of you will live to go and assist in making settlements and build cities and see the Saints become a mighty people in the midst of the Rocky Mountains."[30]

The prophecy began to be fulfilled the moment the Saints set their boots on the trail and continued to be fulfilled after they arrived in the Great Basin. Young led the Mormons westward, and once here they established a church that steadily grew across climes and time zones. In more modern times, the Latter-day Saints have become a respected people, their religion one of the fastest growing Christian denominations in the world.

Once at the park, but before you enter the paid portion that lies beyond the gates of the visitor center, take a look at the other markers that dot the landscape. One of them honors the prophet's Rocky Mountain prophecy, a granite monument reading, "Anson Call was present when the Prophet Joseph Smith uttered the Rocky Mountain Prophecy." Below this inscription are words from Brother Call, engraved on a bronze book-plate fastened to the gray monument:

Monuments

This Is the Place Heritage Park is open to visitors all year. Here, visitors step back in time to recall a period of life that no longer exists and can see firsthand how the Mormon pioneers lived and labored. *Photo by Andy Weeks.*

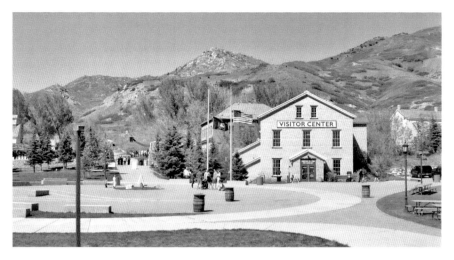

A monument at This Is the Place Heritage Park honors the vision of Joseph Smith in which he proclaimed that the Latter-day Saints would one day become a mighty people in the midst of the Rocky Mountains. *Photo by Andy Weeks.*

On the 14th July [1842] in company with about 50 or 100 of the brethren, we crossed the river to Montrose to be present at the installment of a lodge of the Masonic order, viz, "The Rising Sun." Whilst together, Joseph, who was with us, told us of many things that should transpire in the mountains. After drinking a draught of ice water, he said, "Brethren, this water tastes much like the crystal streams that are running in the Rocky Mountains which some of you will participate of. There are some of those standing here that will perform a great work in that land…There is Anson. He shall go and shall assist in building cities from one end of the country to the other, and you shall perform as great a work as has ever been done

by man, so that the nations of the earth shall be astonished, and many of them will be gathered in that land, assisting in building cities and temples, and Israel shall be made to rejoice. But, before you see this day, you will pass through scenes that are but little understood by you. This people will be made to mourn, multitudes will die and many will apostatize, but the priesthood shall prevail over all its enemies, triumph over the devil and be established upon the earth, nevermore to be thrown down."

Attribution for the text, listed at the bottom, comes "from *The Life and Record of Anson Call* commenced in 1839, p. 22."

THIS IS THE PLACE MONUMENT

In the Old Testament, Moses led thousands of Israelites on the great exodus to freedom, escaping Pharaoh's evil rule. In like manner, Brigham Young led thousands of Latter-day Saints in 1846–47 on a mass exodus westward as they fled persecution in the Midwest. A number of similarities exist between the two faith groups, the main one being that both peoples were led by deep religious stirrings and sought to worship God according to the dictates of their conscience, unmolested by corrupt leaders and apostates. It was no easy task to oversee the great migrations, and at both times now recorded in the history books and in scripture, it took one with vision, unflagging dedication and a zealous resolve to see it through. That man in ancient times was Moses; in modern times it was Brigham Young.

A towering monument at This Is the Place Heritage Park dramatizes Young's entrance into the Salt Lake Valley. He stands stately and bold, by all means presidential, flanked by other brethren of the priesthood as they gaze across the wide and arid expanse of a fertile valley, the Great Salt Lake far in the distance. Here were places just right for farming, where the deer and antelope roamed, where small streams and a great river flowed. We can only imagine what Brother Brigham must have felt as he considered the toil and sacrifice of the Latter-day Saints—their persecution, their 1,200-mile trek, their challenges across the plains—and what blessings then lay before them in their new home, their New Zion. While in his stupor, he saw what Brother Joseph years before saw in vision: the Mormons were home.

Much work had yet to be done, however—homes to construct, fields to sow, businesses to start, churches to build—and it took a man such as

Monuments

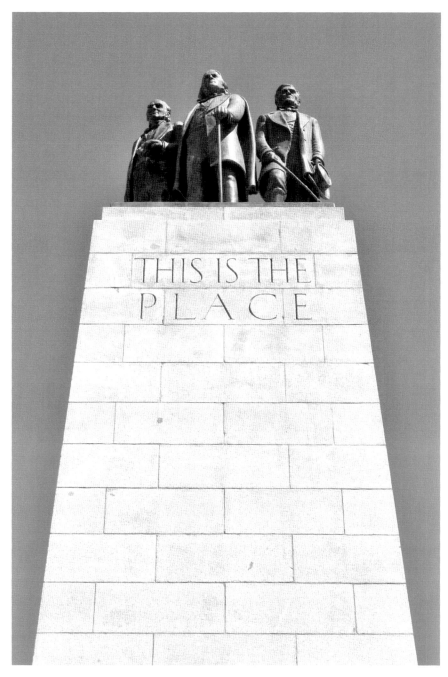

Here's another view of Brigham Young and other brethren as they gaze across the Salt Lake Valley. This emblem at This Is the Place Heritage Park sparks a sense of curiosity as one reflects on the scene as it must have been in 1847. *Photo by Andy Weeks.*

Brigham Young to catch the vision and direct its fruition. It didn't take long before he sent missionaries to opposite ends of the territory to explore and build agricultural communities. Like the honeybee called Deseret named in the Book of Mormon, the Latter-day Saints were an industrious people and out of the desert grew their great empire of faith.

You can catch a glimpse of what Young saw on that momentous day in 1847 as you stand beneath the towering monument, beneath the three statues, wherein are engraved the words, "This Is the Place."

Look in the same direction the statues are facing: you'll see the valley spread before you almost as it did not quite two hundred years ago. The Oquirrh Mountains, which flank the west side of the valley, look primarily the same as they did during the Saints' arrival. So does the great lake far to the northwest. What's different are the established houses, businesses, smoke factories and freeways that clutter the landscape. Still, it is a beautiful valley and its rising out of the desert or, in Book of Mormon terminology, its blossoming as the rose, is indeed a testament to the faith, perseverance and dedication of the Latter-day Saints. The Salt Lake Valley itself has become a monument of faith—to Brigham Young, to those who followed and to all who live and worship here today.

Pioneer Memorials

One of the tragedies of the Mormon Exodus was that many Latter-day Saints, both old and young, died along the way. When the Grim Reaper visited their camps, the lowly family members would have to bury their dead in the barren and cold earth, in places where they, the family members, likely would never visit again. Though they often marked the burial grounds, some of them shallow due to winter's frozen soil, time and nature have wearied away the makeshift tombstones, leaving a swath of unmarked graves along the Mormon Trail.

For those who completed the journey, it was a time of thanksgiving and joyful celebration; and those who lost loved ones along the way still took time to give thanks. For here in the midst of the Rocky Mountains they would be able to attain their dreams unmolested and worship God according to the dictates of their conscience, without mob violence or government interference. Sadly, they had to leave the United States to do so and enter foreign territory. Utah, at the time of the exodus, was part of Mexican Territory.

Monuments

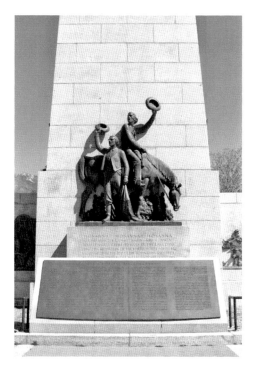

Pioneers are depicted on this monument at This Is the Place Heritage Park. Some of the engravings on the markers also are of fur trappers and explorers who came through the area before the Mormons arrived. *Photo by Andy Weeks.*

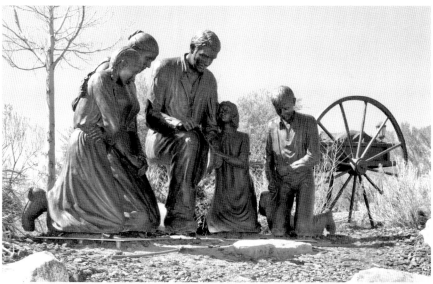

Many pioneers immigrated to Utah during the Mormon exodus of 1846–47. While most of them made it across the plains, some of them lost their lives for their faith. This memorial at This Is the Place Heritage Park depicts a pioneer family giving thanks. *Photo by Andy Weeks.*

A History of Mormon Landmarks in Utah

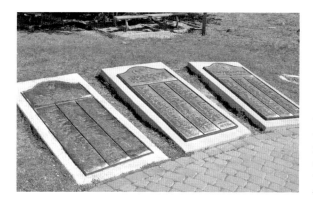

These monuments at the park resemble grave markers and honor names and historic episodes of the early pioneers. *Photo by Andy Weeks.*

At Heritage Park, in a center garden spot, is a sculptor's rendition of a pioneer family giving thanks. All family members, parents and children, are kneeling on the rough terrain, their heads bowed in solemn prayer. What are the words they are saying? Imagine having made the long and tiring trek, the hardships endured and finally coming to rest at the long-foreseen oasis in the desert west where life and circumstance would begin anew. What would your words be as you knelt down to offer words of gratitude and worship? They are likely the same words, or similarly so, to what this pioneer family is eternally saying in its bronze state.

Many other pioneer memorials dot the park, and it'd be well worth your time during a visit to search them out and read their epitaphs. Some of the markers resemble headstones or grave markers, each paying tribute to a pioneer, a group or a mission. A few of them honor those who at various times in the 1900s reenacted the historic trek. Reenactments of the pioneer trek are done every year by some LDS congregations in Utah and elsewhere. Though low-key compared to the big reenactments of former years, such as 1947, these outings give young people an up-close and personal look at what it may have been like to be a pioneer.

Brigham Young Farmhouse

Built in 1863 on some six hundred acres that the prophet owned at about Seventh East and Twenty-third South Salt Lake City, the Brigham Young Farmhouse was relocated to its current settlement in 1975. It was one of many homes owned by Young in Utah Territory and where several of his polygamous wives lived. He would visit and host dignitaries at the home, but for the most part it was the place of residence for a handful of his fifty-seven

wives. It today is one of the more popular attractions at This Is the Place Heritage Park.

"Eventually the farmhouse became surrounded by a residential neighborhood," the Utah Division of State History, writing about historic monuments and markers on its website, explained about the farmhouse.

> *The farm was primarily a dairy farm, making butter and other dairy products for Brigham Young's families in Salt Lake, but it was also an agricultural experimental farm. One of the experiments was with serraculture: raising silk worms to develope* [sic] *the silk industry in Utah. In 1975, the home was traded to the State of Utah for Brigham Young's Winter Home in St. George and was moved to its present location where it has been restored much as it was during the mid-1860s as a working dairy and experimental farm with barns and shed, livestock, fields, pastures and orchards.*

The park is dotted with numerous other buildings of historic significance, including the cozy home of Mary Fielding Smith, wife of Hyrum Smith; and a print shop where early editions of the *Deseret News*, Utah's first newspaper, was published.

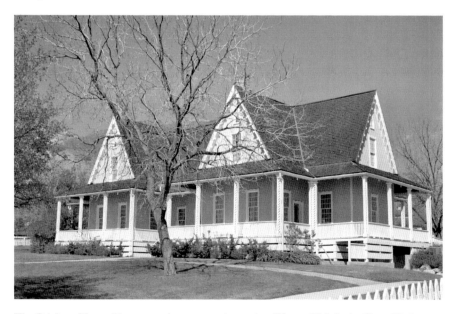

The Brigham Young House, an elegant mansion-style edifice at This Is the Place Heritage Park, is open to park visitors. While it is said that Brother Brigham did not live here himself, several of his polygamous wives did. The house also was used as a place for social gatherings when the family entertained guests. *Photo by Andy Weeks.*

A gravel driveway passes alongside the Brigham Young House at This Is the Place Heritage Park. *Photo by Andy Weeks.*

This Is the Place Heritage Park is home to many historic buildings used by early Latter-day Saints. Visitors can get up close and personal with pioneer life at the park. *Photo by Andy Weeks.*

It is well worth your time to visit each of the buildings and learn something of their past. Don't be surprised if you hear rumors about a haunting or two. Apparently, the past comes alive here in more ways than one.

HAUNTED HERITAGE

I had the pleasure of researching some of the stranger stories of the park, talking with several members of its staff, for my book *Haunted Utah* and thought I'd share them here as well.

Ask a staff member or two and they could probably tell you stories about some of the strange happenings that go on at the park. There is nothing evil here, but they tell stories of things that can't be explained except in the context of the paranormal. More than fifty historic buildings sit on the 450-acre parcel. Many of these buildings allegedly have resident ghosts.

Brigham Young Farmhouse

Balls of self-illuminating light have been seen floating in the upstairs rooms of the 1860s-era Brigham Young Farmhouse, said historical interpreter Kendra Babitz. She witnessed the lights one night while waiting for visitors in October 2008. Though the balls of light were seen during a Halloween attraction, she said there is no logical explanation for what she witnessed. She was the only person in the house at the time, and the lights grew and dimmed as they floated on the second story.

Babitz said she believes the entities in the farmhouse could be the spirits of children. It is believed that Brigham Young never lived in the farmhouse

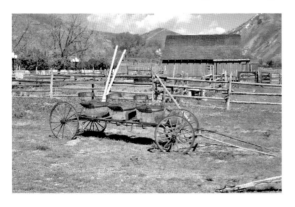

The past comes alive at This Is the Place Heritage Park, where visitors can walk the grounds to see historic buildings, artistic sculptures and period farm equipment like this wagon. *Photo by Andy Weeks.*

himself, but his many wives did. Young is reported to have had fifty-seven wives. Each took turns living in the house. "They never lived there together," Babitz said. Young did use the house, which originally was located in present-day Sugarhouse, as a showplace to host dignitaries. The upstairs was used as a play area, where the children often hung out. The house was moved to the park in the mid-1970s, and over the years there've been a number of strange occurrences reported in the house, and the self-illuminating balls of light story is only one.

Hiram L. Andrus Home

The spirit, presumably that of a woman, likes things quiet after nine-thirty at night in the Hiram L. Andrus home. On more than one occasion during special events at the park, staff would plug the cord of a small stereo into the walls to play music inside the house. Then, when they least expected it, the music would all of a sudden stop playing. When staff would go to check why the music had stopped, they'd find the stereo unplugged, the cord lying two feet away from the wall. No one else was inside the house to play the prank, Babitz said. They'd plug the cord back into the wall and the stereo would play. They'd leave the room and the music would stop. When they returned they'd fine the cord again unplugged.

Like the Young house, Babitz said she's never felt anything malevolent at the Andrus home, though she sometimes has felt unwelcome, as if the resident ghost was saying, "This is my house and you don't belong here"—especially after nine-thirty at night. Maybe that is the ghost's bedtime, or the time in life when she put the children to bed.

Mary Fielding Smith Cottage House

"Diamond" Jim Davis, another historical interpreter, said he's experienced a number of unexplained phenomena since he started working at the park. Some of his experiences include hearing phantom footsteps, being the center of ghostly pranks and seeing an apparition. He recounts his experiences, saying, "I never used to believe in the paranormal until I started working at Heritage Park."

His witness of an apparition happened one snowy February morning. While driving up the hill toward the Mary Fielding Smith house, he saw a

Mormon Battalion soldier dressed in period clothing. He at first thought the figure was an actor, because a film crew had recently been filming on park grounds, but as he came closer to the house the image slowly faded.

Mary was the wife of church patriarch Hyrum Smith, who had been killed with his brother Joseph in Carthage, Illinois. She was a devout and strict woman. Because the Latter-day Saints had been driven by mobs from their former homes, Davis said, Mary seemed to take great pride in the home she established in the Salt Lake Valley. Her home was first located at 2700 South 1300 East and moved to the park in about 1979–80. Davis said he believes the spirit he saw that wintry morning was a former member of the Mormon Battalion sent to guard Mary's house.

B.F. Johnson Saddlery

Davis shares another memorable experience, this one occurring one day while working in the park's saddle shop. As often is the case, he was working alone, trying to put together a leather knife sheath. But it wasn't going well, he said. The glue wasn't holding.

After a few minutes of trying to get the glue to hold, he left the building frustrated, returning about twenty minutes later. To his surprise, he found the sheath lying on a chair, glued together. His first thought was that someone else at the park completed it for him, but only two other people were on the grounds that morning—a desk worker and a visitor, both in other buildings. Besides, he said, how could another person make the glue stick when he couldn't?

Catching Glimpses

If you haven't been to the park, you've missed something. And as paranormally active as the park might be, weird things don't occur every day, Babitz said. And they don't usually occur if you're expecting them to. When they do happen, it's when staff least expect them, often while they go about their responsibilities, their minds focused elsewhere.

Babitz and Davis both said they've never felt threatened at the park—and the stories they've heard from other staff members are the same—but they can't explain the weird things they've experienced. Asked if he believes if there are any conflicts with Mormon theology and his experiences with the

paranormal, Davis said no. Mormons believe God has a plan for human beings, including their spirits once they die. They believe the spirit world is on the earth, same as mortals, only in another sphere. "It makes sense that if they're here," Davis said, "perhaps we can catch glimpses of them from time to time."

TEMPLE SQUARE AND NEARBY MONUMENTS

The most popular tourist destination in the Beehive State is also one of the country's most popular. You don't have to take my word for it; the subject made headlines in a news article dated March 12, 2009. "In spite of a struggling economy, 5 million visitors made Temple Square the 16th most visited site in the United States, according to Forbes," reads the *Deseret News* article by Aaron Falk. "At Temple Square, tourists—Mormon or otherwise—come from around the world…In 2007, the square saw visitors from 83 countries and each of the 50 states, according to the LDS Church."

Though these numbers are a bit dated, the fact remains: Temple Square continues to be Utah's most popular tourist spot and a favorite in the country. There are several possible reasons for this: Mormons who live in other parts of the country come here to see their faith's headquarters; non-Mormons, out of speculation or curiosity, visit to learn something about the faith; and tourists in Utah, religious or not, mark it as one of their must-see stops while visiting the Beehive Sate for the simple fact that it is part of history. Even active members of the faith who reside in Utah come here for family or church outings, holiday or other religious activities, choir or other concerts or to just ponder and pray near the emblems of faith.

No matter why they come, visitors usually walk away with questions answered, pictures taken and, in some cases, a newfound respect for the Mormon Church. Some people not of the LDS faith have come to Temple Square with misconceived notions about the church, only to leave with a better understanding and insight into the true nature of its worship methods

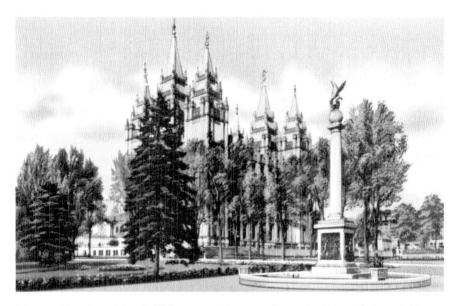

Mormon Temple and Sea Gull Monument. Carpenter Paper Co. Postcard. *Boston Public Library Tichnor Brothers collection #69160.*

and teachings. Mormons, for instance, do believe in the Holy Bible and regard Jesus Christ as the Son of God, the Savior and Redeemer of the world. One of the most popular items at the square is a tall and reverent statue of Jesus.

THE CHRISTUS

You cannot help but ponder the Lord's creations and your place in his divine plan when visiting the upper level of Temple Square's North Visitor Center. Here, in a circular room painted to look like the magnificent universe, stands an eleven-foot statue of Jesus Christ, who Latter-day Saints believe helped shape the infinite galaxies under the direction of God, our Heavenly Father. "And worlds without number have I created; and I also created them for mine own purpose; and by the Son I created them, which is mine Only Begotten."[31]

The statue by Bertel Thorvaldsen, called *The Christus*, was first created in 1838 for the Church of Our Lady in Copenhagen, Denmark, but replicas were later adopted by the LDS Church after Stephen L. Richards purchased a replica and presented it as a gift to President David O. McKay. The church

placed it at Temple Square in 1966 and replicated it for various temple sites throughout the world.

The statue is something that visitors most remember; it is itself symbolic of the central place Jesus Christ plays in Latter-day Saint worship: he is the center of their devotion—as Son of God, Savior and Redeemer of the world, Promised Messiah, King of Israel and of all humanity. "I am the way, the truth and the light," Christ told his apostles during time's meridian, "no man cometh unto the Father but by me."[32] Mormons, whose church is officially named after the Christ, wholeheartedly believe this. The Book of Mormon, which, as its subtitle suggests, is another testament of Jesus Christ, contains more references of Christ being the Savior than does the Bible. In the pinnacle episode of the book, Jesus visits the ancient Americas soon after his resurrection in the Holy Land, fulfilling his promise made in Jerusalem to visit the "other sheep"[33] of his Father's fold, who were scattered throughout the world. When he appears, he tells the people, who called themselves Nephites after their primary prophet, "Behold, I am Jesus Christ, whom the

The central figure in Mormon worship is Jesus Christ. The north side visitor center at Temple Square is dedicated to Christ, and through sculpture and paintings, his life is depicted. The most famous piece is *The Christus*, an eight-foot-tall statue of Christ set against a mural of the expansive universe. In part, it depicts Christ's almighty power as the creator, under the Father's direction, of worlds without number. *Photo by Andy Weeks.*

prophets testified shall come into the world. And behold, I am the light and the life of the world; and I have drunk out of that bitter cup which the Father hath given me, and have glorified the Father in taking upon me the sins of the world, in the which I have suffered the will of the Father in all things from the beginning."[34]

The church's first prophet, Joseph Smith, and his counselor Sidney Rigdon testified they had seen Jesus in vision while at the temple in Kirtland, Ohio, on February 16, 1832. While enveloped in the heavenly vision, they beheld the Savior standing on the breastwork of the pulpit inside the temple. Their testimony—in the mouth of two or three witnesses shall every word be established[35]—which they left for the world is this: "And we beheld the glory of the Son, on the right hand of the Father, and received of his fulness;...And now, after the many testimonies which have been given of him, this is the testimony, last of all, which we give of him: That he lives! For we saw him, even on the right hand of God; and we heard the voice bearing record that he is the Only Begotten of the Father—That by him, and through him, and of him, the worlds are and were created, and the inhabitants thereof are begotten sons and daughters unto God."[36] It was one of several visions the prophet had of the Savior.

For the Latter-day Saint, Christ was not only a prophet, a moral teacher and exemplar of virtue, a good man. He was and is the eternal Christ, who was literally resurrected after his crucifixion and soon thereafter appeared to his apostles in Jerusalem and people of faith in the New World. Mormons believe he restored his ancient gospel to the earth through the instrumentality of Joseph Smith and directs it by revelation today through Smith's successors. He is a living and active Christ, not a dead and immobile one.

The Christus at Temple Square, where there also are murals that depict the life of the Messiah, reminds us of the centrality of Jesus Christ in our Heavenly Father's plan, his centrality in Latter-day Saint worship and the central place he should play in all our lives—if we but allow him. "Knock," the Savior said, and the door "shall be opened unto you."[37]

The Tabernacle

It's an easily recognizable landmark, often seen in photos with the Salt Lake Temple such as the one complementing this section. The historic Mormon Tabernacle at Temple Square, a dome-shaped building erected between 1864 and 1867, has many notable trademarks, including the wooden dowels

Monuments

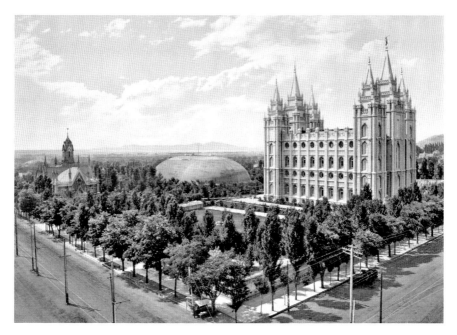

A view of Temple Square in 1899. *Photochrom print. William Henry Jackson.*

and wedges used in its construction. Its 9-foot-thick dome-shaped roof, some 150 feet wide and 250 feet long, gives cover to a seating capacity of around seven thousand.

For decades before the much larger Conference Center was built north of Temple Square, the Tabernacle hosted the church's annual and semi-annual general conferences. From its pulpit, apostles and prophets addressed the growing church membership, expounded doctrine, announced revelation, shared stories, instructed Latter-day Saints and commanded in the name of the Lord.

Wooden pews and the scent of yesteryear remain in the building, while modern community residents and church members gather inside the historic building for church and civic functions. The most popular takes place every Sunday, just as it has for years: the church's famous choir raises its unified voice in hymn and worship.

THE FAMOUS CHOIR AND ITS ORGAN

Known the world over for its harmonious, reverent and sometimes thunderous renditions, the Mormon Tabernacle Choir has put a face to Mormonism since the choir's inception in 1847. The small choir that Brigham Young formed first performed at a church gathering on August 22 of that year. Now it is an army of talents, still putting a face to Mormonism.

On occasion choir members—some 360 choristers in all—travel to distant lands to spread their message of faith and good cheer. When at home, they gather in the historic tabernacle at Temple Square to raise their voices for a weekly broadcast called *Music and the Spoken Word*, which started broadcasting in 1929. People of many faiths enjoy the hymns of reverence and inspiration, tuning in every week to hear the message. Amid their strong voices is the reverent but powerful strain of a many-thousand multi-pipe organ that visibly is the background of the choir. An entry on the choir's website, Mormontabernaclechoir.org, explains a little about this iconic organ.

> *Complementing the voices of the 360 choristers who comprise the Mormon Tabernacle Choir is the sound of the majestic Tabernacle organ—one of the world's largest and most distinctive instruments.*
>
> *Much more than an icon, the organ and its 11,623 pipes breathe a warm, refined sound that blends perfectly with the voices of the Choir.*
>
> *Located in the historic Tabernacle on Salt Lake City's Temple Square, the organ is a massive, yet intricate instrument. Together with the Tabernacle itself, the organ is in no small way responsible for the signature sound of this world-renowned choral ensemble.*
>
> *The original organ was built by Joseph Ridges, an English convert to The Church of Jesus Christ of Latter-day Saints who came to Salt Lake City by way of Australia. Ridges' modest instrument, built with old-world craftsmanship and a liberal dose of pioneer ingenuity, was constructed of materials native to the region as far as possible. Though the organ has been rebuilt and enlarged several times during its 135-year history, the original casework and some of Ridges' pipes still remain in the organ today.*

When the church holds its semi-annual and annual conferences, now in the Conference Center, there amid prophets and apostles where another massive organ and pipes are displayed, members of the famous choir again lend their faith in musical melodies.

Visit the church website for concert tours, many of which are performed in the Tabernacle. The site seems to receive special focus during the holidays when the sounds of Christmas cheer are raised under its iconic roof and melodious strains of music emanate from the pipe organ. It is wondrous to hear. Many other concerts are held in the nearby Assembly Hall, another historic and memorable building at Temple Square.

Assembly Hall

On the southwest corner of temple block stands the Assembly Hall, but it wasn't always so. Before the current building was constructed there stood a bowery or series of poles and braces supporting "an immense quantity of leafy branches of trees, which composed the roof and served to shelter the congregation of earnest worshippers from the rays of the summer sun," reported the *Millennial Star*, a church newspaper at the time. Nearby stood an adobe tabernacle, later called the "Old Tabernacle" after the current one was built.[38]

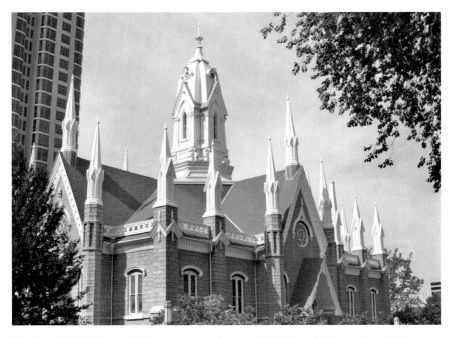

The Assembly Hall, an artistic structure on the grounds of Temple Square, is used for many church and community gatherings throughout the year. *Photo by Andy Weeks.*

A History of Mormon Landmarks in Utah

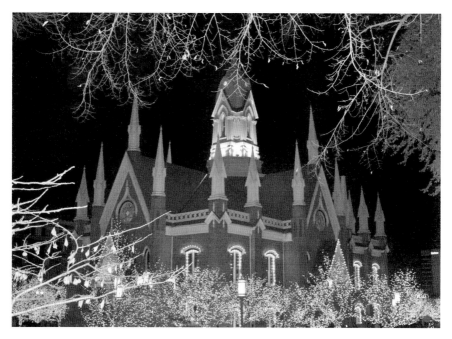

The Assembly Hall at Temple Square at Christmastime. *Photo by Brian Davis.*

On August 11, 1877, Brigham Young proposed that a new building be erected at Temple Square to accommodate the growing membership of the church and serve local Latter-day Saints. The bowery was razed and up went the Assembly Hall. Church members were thrilled by the new building. Not only did it offer a larger seating capacity with more elegant craftsmanship, but with its steam heating system it better fought off winter chills for the Saints who sat in conference during church gatherings. In 1882, the *Deseret News* reported that President John Taylor, third president of the church, instructed the Saints to meet during a session of the church's October general conference in the Assembly Hall because the church was "unable to warm the Tabernacle…If the weather was warmer on Saturday," Taylor instructed, "we would meet in the Tabernacle, when all should come well clothed."

Young, because the Grim Reaper visited him just eighteen days after he announced construction of the new building, never saw work begin on the structure that today is named the Assembly Hall. It is one of many buildings that he commissioned, however, and one that stands in all the elegant glory of yesteryear.

Temple History and Baptismal Font

In the South Visitor Center are renderings, displays and kiosks about the construction and purpose of the Salt Lake Temple and the importance of family. While here, visitors also get an up-close and personal look at the replica of a baptismal font used in modern-day LDS temples. Fonts like this one, which sit on the back of twelve oxen that represent the twelve tribes of Israel, are used in Mormon temples throughout the world for proxy baptism, sometimes referred to as baptism for the dead.

Baptism for the dead is unfamiliar in modern Christendom and because of its allure is often thought of as an unorthodox or cult practice. It is one of the least understood practices of Mormon theology, even though its foundation is taken from the New Testament. The Apostle Paul, teaching of Christ and a universal resurrection, asked the question: "Else what shall they do which are baptized for the dead, if the dead rise not at all? Why are they then baptized for the dead?"[39] In essence, he was saying if there was no resurrection then it matters little if proxy baptism is performed. But since there will be a resurrection, it matters a great deal as all men and women will one day stand before the judgment bar of God and give an accounting of their acceptance or denial of gospel laws. The same practice, baptizing on behalf of the deceased, has been restored to the earth in the latter days through the instrumentality of Joseph Smith.

"Jesus Christ taught that baptism is essential to the salvation of all who have lived on earth (see John 3:5). Many people, however, have died without being baptized," the church explains on its website. "Others were baptized without proper authority. Because God is merciful, He has prepared a way for all people to receive the blessings of baptism. By performing proxy baptisms in behalf of those who have died, Church members offer these blessings to deceased ancestors. Individuals can then choose to accept or reject what has been done in their behalf."

What about those deceased persons who are baptized but who in this life may not have wanted to be? The church explains: "Some people have misunderstood that when baptisms for the dead are performed, deceased persons are baptized into the Church against their will. This is not the case. Each individual has agency, or the right to choose. The validity of a baptism for the dead depends on the deceased person accepting it and choosing to accept and follow the Savior while residing in the spirit world. The names of deceased persons are not added to the membership records of the Church."

The Grounds and Statues

While touring Temple Square, pay attention to the details—the pleasant flowerbeds where weeds are practically nonexistent; the symbolism on the façade of the Salt Lake Temple such as the sun, moon and stars that represent the three degrees of glory and the all-seeing eye, among other symbolisms; and the several statues and markers that exist on the grounds such as a statue that depicts Joseph Smith being visited by Peter, James and John as they lay their hands upon his head, authorizing him with the Melchizedek Priesthood. There are other monuments scattered throughout Temple Square, including statues of Joseph and Emma Smith and markers that memorialize the pioneers and the seagull episode in early church history.

Church Office Building

It took $31 million and ten years for the twenty-eight-story Church Office Building to be completed. Construction began in 1962 during the administration of David O. McKay and was completed in 1972, the year Harold B. Lee succeeded Joseph Fielding Smith as president. At the time of its completion, the church had around three million members worldwide; as of this writing there are more than fifteen million. The building is used for administrative functions such as the production of church-related materials and the facilitation of missionary work.

The thing that catches people's attention when visiting the lobby of the building is a large mural called *The Great Commission*. It depicts Christ on the Mount of Olives shortly after his resurrection and before his ascension into the heavens. Before he departs, he charges his apostles with the mission to carry the gospel message into all the world. It was the beginning of missionary work in the early church.

Today, young men eighteen years or older and young women nineteen years or older in good standing with the church and who wish to serve are called by the First Presidency and Quorum of Twelve Apostles to various church missions throughout the world. While the call is prompted through prayer and revelation, there are many procedural items that need to be taken care of, such as writing the assignment letters and sending them to the soon-to-be-missionary. The letter assigns the area to which the chosen missionary will serve and length of service and provides additional information about

MONUMENTS

Right: Statue of Joseph Smith, founder of The Church of Jesus Christ of Latter-day Saints, on Temple Square in Salt Lake City, Utah. *Wikimedia commons.*

Below: The Church Office Building, headquarters of the LDS Church, stands twenty-eight stories high in downtown Salt Lake City. *Photo by Andy Weeks.*

the assignment. On the façade of the building is a map of the world, reminding visitors of the worldwide membership of the church and its commission to take the restored gospel into all nations, thus the purpose of modern missionary work.

Something else in the lobby that catches people's attention is a statue of a pioneer couple burying their child. It is placed in remembrance of the early Saints, "That the struggles, sacrifices and sufferings of the faithful pioneers and the cause they represented shall never be forgotten."

When visiting, be sure to take an elevator ride to the observation deck on the twenty-sixth floor where a bird's-eye view of the Salt Lake Valley is beholden to you. It's a sight not easily forgotten.

Church Administration Building

Salt Lake City is known as the headquarters of the LDS Church because it is here where its highest-ranked governing officials preside, the First Presidency and Quorum of Twelve Apostles. It is here where, in Isaiah's language, goes "forth the law, and the word of the Lord from Jerusalem."[40] Every April and October, church leaders meet at the Conference Center to address members of the worldwide church, their counsel being broadcast through satellite and Internet to the far reaches of the earth, which in the digital age doesn't seem that far at all. It is in Salt Lake City where administrative, budgetary and policy issues are planned and implemented; where missionary work is directed; and where organizational matters are decided—and much of it happens in the Church Administration Building.

Made of quartz monzonite hued from the same quarry in Little Cottonwood Canyon as the stone used to construct the Salt Lake Temple, the Church Administration Building, which has twenty-four columns forming a colonnade around the facility, was built in 1917 to house the offices of the First Presidency, members of the Quorum of Twelve Apostles and other general authorities and their staff. It is located between the Joseph Smith Memorial Building and Brigham Young's Lion House. Unlike other buildings in the vicinity, only church officials can enter the Church Administration Building, sometimes abbreviated as the CAB, and it has often been the locale of meetings with the country's political leaders and other notable figures.

The Church Administration Building houses the offices of the First Presidency and members of the Quorum of Twelve Apostles, the church's highest ranking officials. *Photo by Andy Weeks.*

THE CONFERENCE CENTER

"The most common first impression of the new Conference Center is awe at its size. The first party of pioneers that entered the Salt Lake Valley in July of 1847 could probably have camped within the space covered by the structure. A 747 jetliner could fit inside the auditorium, and the Tabernacle on Temple Square could fit within the auditorium's rostrum area." This was the description that Don L. Searle, assistant managing editor for Church Magazines, gave of the newly constructed LDS Conference Center in an October 2000 article.

He continued:

> *And yet that initial feeling of awe at the size gives way to a stronger impression when visitors take part in the meetings for which the Conference Center was primarily built. This is unmistakably a house of worship. The feeling of faith is almost like a warm blanket when some 21,000 Latter-day Saints (three times the number that could squeeze into the Tabernacle) gather to hear the counsel of living prophets and apostles and sing the hymns of Zion.*[41]

A History of Mormon Landmarks in Utah

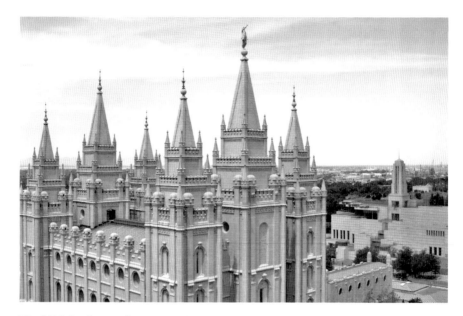

The LDS Conference Center, seen in the background of this photo. Ever since it was built in the 1990s, it has been the place where the church's annual and semi-annual general conferences are held. Formerly, they were held in the Tabernacle on Temple Square. *Photo by Andy Weeks.*

Construction on the 1.4 million-square-foot conference center started in 1996 and was completed in early 2000, just in time for that April's general conference. The center is believed to be largest theater-style auditorium ever built and is a legacy of President Gordon B. Hinckley, fifteenth president of The Church of Jesus Christ of Latter-day Saints. Hinckley, who started considering a large-scale center in the early 1990s, announced its construction to church members at the April 1996 General Conference. One of his personal touches to the building: he donated wood from a black walnut tree he planted years earlier in his backyard; it was used to construct the pulpit.

Behind the pulpit is a rostrum that seats 158 members of the church's general authorities and officers; plus there's room for the 360-member Mormon Tabernacle Choir with the backdrop of a 7,667-pipe organ.

The Conference Center is big, elaborate and a monument of faith to the Mormons the world over.

Joseph Smith Memorial Building

A tall white statue of the prophet stands stately in the elegant, gold-trimmed foyer of the Joseph Smith Memorial Building. A person with talent in his or her fingers often will play the room's piano, sending melodious strains of music across the marble-tiled floors. It's an elaborate building once called Hotel Utah—ten stories on the corner of Main Street and South Temple—that was remodeled in the 1990s as a church-functioning facility in honor of Mormonism's founder.

Even before Hotel Utah opened in 1911, however, the site was used for church purposes. A bishop's storehouse once resided here, as did a tithing office and printing plant for the church-owned *Deseret News*. When the Los Angeles architectural firm of Parkinson and Bergstrom contacted Salt Lake about constructing a grand hotel on the property, the Mormon Church jumped on board as one of its shareholders. Work began in June 1909, and the steel-structure building, complemented with glazed terra cotta, was completed two years later in June 1911. Interestingly, the hotel was reported to have one of the finest bars in the country—a far cry from the building's amenities today because of the church's tenet to avoid alcohol, among other potentially harmful substances.

The author's son, Brayden, stands in front of a towering statue of Joseph Smith during a visit to the historical Joseph Smith Memorial Building in downtown Salt Lake City. *Photo by Andy Weeks.*

The building was added to the National Register of Historic Places on January 3, 1978, as Hotel Utah but today is known among local Latter-day Saints as a place of church administrative and genealogical research offices. In the 1990s, the church produced an hour-long film called *Legacy* about early Mormon converts and their trek westward. The film was shown almost daily for several years to visitors free of charge at the Memorial Building. Later, another film replaced the first, this one called *The Testaments*, a story about the Book of Mormon. Both films are now on DVD and available at minimal cost online and through church distribution outlets.

The Joseph Smith Memorial Building also has modern restaurants with picture windows that offer bird's-eye views of the valley, and receptions and various other celebratory events are held within its fine dining and banquet rooms. On the top level, windows at both west and east ends give visitors spectacular views of the cityscape. The west side is most popular, where you can look on the historic site of Temple Square, the Salt Lake Temple seeming as if it were almost at arm's reach.

The Beehive House/The Lion House

When Young and his several wives arrived in the Great Salt Lake Valley, he built a mansion-style house at Temple Square, the hub of church activity for the newly arrived church members. At this same locale would eventually be constructed a domed tabernacle, church offices and Utah's fourth LDS temple—a granite stone edifice engraved with symbolism and spires that reach toward heaven. As for Young's houses, he eventually had several including the Beehive House, an adobe and sandstone structure, and the larger Lion House.

Built about 1854, the Beehive House was designed by Truman O. Angell, Young's brother-in-law most popularly known for his architectural vision of the Salt Lake Temple. Angell also designed Young's second home, the Lion House, built in 1856 to better accommodate his growing family, which stands adjacent to the Beehive House one block east of Temple Square in downtown Salt Lake City. It contained twenty rooms on the second level, while the ground floor offered spacious room for family gatherings. Both homes are connected by a suite of rooms, including what was used as Young's office and his bedroom where he died in 1877.

The homes, furnished in period décor, are open to the public. But there's modernity here, too. Today, the Lion House hosts special events. Don't forget to try the delicious food served in the Lion House Pantry and catering services.

Relief Society Building

On March 17, 1842, Joseph Smith created the LDS Relief Society—an organization of women that has been hailed as the largest in the world. "The

church was never perfectly organized until the women were thus organized," the prophet said. The official organization came on the heels of a society that some of the sisters of Nauvoo sought to create that same spring while church members were "busily occupied with the work of building the Nauvoo Temple," reads *Teachings of Presidents of the Church: Joseph Smith*. "Two such members were Sarah Granger Kimball and her seamstress, Margaret A. Cook, who, while talking together one day, decided to combine their efforts in order to help the temple workmen. Sister Kimball said that she would provide fabric so that Sister Cook could make shirts for the men. The two women decided to invite other sisters to join them in forming a ladies' society to further their benevolent efforts."[42]

Each branch and ward of the church throughout the world has sisters in the local Relief Society, "whose object," reads an April 1, 1842 editorial published in the *Times and Seasons*, of which Joseph Smith was editor,

> *is the relief of the poor, the destitute, the widow and the orphan, and for the exercise of all benevolent purposes…There was a very numerous attendance at the organization of the society, and also at the subsequent meetings, of some of our most intelligent, humane, philanthropic and respectable ladies; and we are well assured from a knowledge of those pure principles of benevolence that flow spontaneously from their humane and philanthropic bosoms, that with the resources they will have at command, they will fly to the relief of the stranger; they will pour in oil and wine to the wounded heart of the distressed; they will dry up the tears of the orphan and make the widow's heart to rejoice.*
>
> *Our women have always been signalized for their acts of benevolence and kindness;…in the midst of their persecution, when the bread has been torn from their helpless offspring by their cruel oppressors, they have always been ready to open their doors to the weary traveler, to divide their scant pittance with the hungry, and from their robbed and impoverished wardrobes, to divide with the more needy and destitute; and now that they are living upon a more genial soil, and among a less barbarous people, and possess facilities that they have not heretofore enjoyed, we feel convinced that with their concentrated efforts, the condition of the suffering poor, of the stranger and the fatherless will be ameliorated.*[43]

The general Relief Society Building, which honors women of the church, is located at church headquarters on Temple Square in Salt Lake City. It houses church offices and a resource center for visitors, where you can learn

more about the society's purpose and organization as well as tips for personal and family fulfillment.

Groundbreaking for the building, which was constructed because of generous donations from many people, took place on October 1, 1953. It was completed and dedicated in the summer of 1956 and serves as a monument of faith to women of the LDS Church worldwide.

The Salt Lake Temple

For the Latter-day Saint, there is no more holy place on earth, next to our own homes, than the temple. Specially dedicated, temples serve as houses of the Lord, places he may visit—either through the Holy Spirit or in person—to speak with his prophet. The most popular of the church's temples is the gothic castle-like structure at Temple Square called the Salt Lake Temple.

Though plans to build the temple were announced on July 28, 1847, just a few days after Brigham Young and other Latter-day Saints arrived in the Salt Lake Valley, the site dedication and groundbreaking for the edifice did not take place until February 14, 1853. It seems that everything came slowly for this magnificent house of the Lord, for it would take forty years to complete. Brigham Young, who for several years oversaw the temple's construction, did not get to see it completed. After he died on August 29, 1877, Wilford Woodruff was appointed the church's third president and conducted dedication ceremonies for Utah's most famous temple between April 6 and 24, 1893.

Granite to build the edifice was quarried from the nearby mountains, hauled by wagon and shaped and designed on site. The architectural design of the structure came from Truman O. Angell. As dramatized in the church movie *The Mountain of the Lord*, Young became frustrated with the building process when, after months of work, he learned that cracks in its foundation would make continued construction useless. He was determined to build the temple, however, and shrugged off this new trial. He ordered the foundation removed and a new one built. The work continued but experienced other stops along the way. At one point, hearing that a band of federal soldiers was making its way through the valley, Young had the foundation of the temple buried. He feared the former persecutions would revisit the Saints and that those coming to the valley would seek to destroy the temple. When the band finally left, the temple foundation was uncovered—a time-intensive feat in itself.

Monuments

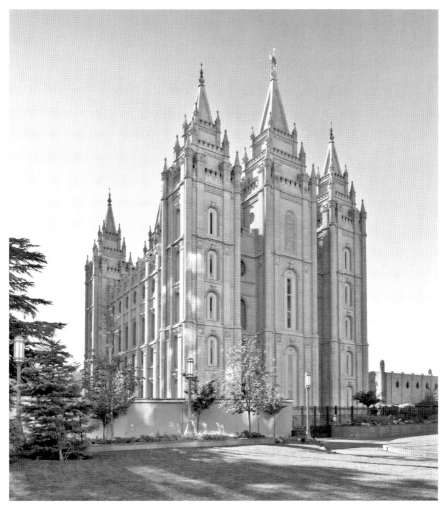

The Salt Lake Temple of The Church of Jesus Christ of Latter-day Saints. *Photo by David Iliff. License: CC-BY-SA 3.0.*

The Salt Lake Temple was the first such structure announced in Utah, but it was the fourth one completed. Temples in St. George, Manti and Logan were all started and completed during the construction of the Salt Lake Temple. It remains the largest of the church's temples and has become something of an icon or symbol of the worldwide church. There are symbols themselves that dot this gray granite monolith, and it doesn't take a trained eye to see the battlements, constellations, earthstones and religious decorations that decorate its façade. Inside, painted murals ornately adorn

endowment rooms, and the entire building is elaborately decorated with the finest craftsmanship of the time. If this was to be a house of God—which it was and is—no expense or talent would be spared. The Saints gave their best effort to build this magnificent temple, a place wherein they believed the Lord himself could visit if he was so inclined.

According to Lorenzo Snow, fifth president of the church, that is exactly what happened one night while he worked in the building. Sometime after the incident, when his granddaughter Allie was visiting him in the temple, he shared the sacred experience. As retold by LDS writer Susan Arrington Madsen in the August 1993 issue of the *Friend* magazine, a church periodical for young people:

> *When Allie was ready to leave, President Snow went to a dresser and took a large bunch of keys from the drawer so that he could let her out the main entrance. Together they walked down a large corridor near the celestial room. President Snow suddenly stopped and said, "Wait a moment, Allie. I want to tell you something." Allie listened intently as her grandfather told her of an unforgettable experience he had once had at that place in the temple: "It was right here that the Lord Jesus Christ appeared to me at the time of the death of President Woodruff. He instructed me to go right ahead and reorganize the First Presidency of the Church at once and not wait as had been done after the death of the previous presidents, and that I was to succeed President Woodruff* [as President of the Church].*"*
>
> *President Snow held out his left hand and said, "He stood right here, about three feet above the floor. It looked as though he stood on a plate of solid gold."*
>
> *Still speaking in hushed, reverent tones, President Snow told Allie that the Savior's appearance was so glorious and bright that he could hardly look at Him.*
>
> *President Snow put his right hand on Allie's head and said, "Now granddaughter, I want you to remember that this is the testimony of your grandfather, that he told you with his own lips that he actually saw the Savior, here in the temple, and talked with him face to face."*[44]

A HISTORIC LOOK AT TEMPLES

Before more spiritual experiences in LDS temples are discussed, and because of their sacred nature in Latter-day Saint worship, it's important to give some background of the history of temples as revealed in scripture and interpreted through Mormon doctrine. Though a bit lengthy, this next section will help the reader see why Latter-day Saints feel the way they do about their temples, which in their theology are not really their edifices at all but tributes to and literally houses of the Lord. Much of the information in this section is taken from a book I wrote several years ago, titled *Spiritual Temples: Heavenly Experiences in the Houses of God.*

Temples in Ancient Times

Whenever the true gospel and church of Jesus Christ have been upon the earth, so also have there been the ordinances of God that save and exalt his children. The ordinances of the highest order are, according to the Mormons, those that relate to temples, holy edifices dedicated to the work of God. Temples are similar to churches, yet very much different.

A person doesn't need a recommend to enter a chapel, but one does need a recommend to enter a Latter-day Saint temple. The reason: temples are specially dedicated places wherein the sacred saving ordinances of the gospel are performed for both the living and the dead; they are places where past and present meet. Churches are built for sinners; temples are used by the

worthy repentant. In short, temples are places where eternal covenants are made for both the living and the dead.

A temple is a house of God. It is "a house of the Lord; a house for Deity that is built on earth; a house prepared by the saints as a dwelling place for the Most High, in the most literal sense of the word; a house where a personal God personally comes," Elder Bruce R. McConkie explained in the first volume of his hallmark Messiah Series.

> *It is a holy sanctuary, set apart from the world, wherein the Saints of God prepare to meet their Lord; where the pure in heart shall see God, according to the promises; where those teachings are given and those ordinances performed which prepare the saints for that eternal life which consists of dwelling with the Father and being like him and his Son.*
>
> *The teachings and ordinances here involved embrace the mysteries of the kingdom and are not now and never have been heralded to the world, nor can they be understood except by those who worship the Father in spirit and in truth, and who have attained that spiritual stature which enables men to know God and Jesus Christ, whom he hath sent.*[45]

Referring to Malachi 3:1—"The Lord, whom ye seek, shall suddenly come to his temple"—McConkie noted, "When the Lord comes from heaven to the earth, as he does more frequently than is supposed, where does he make his visitations? Those whom he visits know the answer; he comes to one of his houses."[46] Thus a temple—God's house on earth—is where he comes when he wants to visit his children; temples are places where he speaks to his prophets. And temple ordinances are the highest order of divine worship. These truths are not made up by the Latter-day Saints; they are truths that stretch through the history of pre-Christianity, with temples playing a significant role during the rise of the Christian era and in the life of Christ.

Though there is no record of temples before the flood, it is assumed there must have been temples anyway. The idolatrous people who built the Tower of Babel likely got their idea from knowing of temples and the closeness to the Lord they allow for the true worshiper. Elder McConkie noted, "Temples constructed before the flood of Noah were obviously destroyed in that great deluge; those built by the Jaredites and Nephites are buried in the jungles and lost in the wilderness of the Americas."[47]

Atop the Mountains

There have been instances in the earth's history when the Saints of God did not have access to temples. At those times the Lord allowed for the sacred work usually reserved for temples to be performed atop mountains, the natural temples of the earth. Such was the case with Moses when he "came to the mountain of God, even to Horeb." The Lord commanded, "Put off thy shoes from off thy feet, for the place whereon thou standest is holy ground."[48]

Elder James E. Talmage, in his book *The House of the Lord*, wrote that "Sinai became a sanctuary of the Lord while He communed with the prophet, and issued His decrees."[49] Likewise, the writings of Moses as contained in the Pearl of Great Price explain that Moses was "caught up into an exceedingly high mountain, And he saw God face to face, and he talked with him, and the glory of God was upon Moses."[50] It is even recorded that at one time the children of Israel witnessed "the glory of the Lord," how it "abode upon mount Sinai...like devouring fire."[51]

Moses, however, wasn't the only one to be enlightened atop a mountain. "Turn ye, and get upon the mount Simeon," the Lord instructed Enoch. "And it came to pass that I turned and went up on the mount," the prophet said, "and as I stood upon the mount, I beheld the heavens open, and I was clothed upon with glory; And I saw the Lord; and he stood before my face, and he talked with me, even as a man talketh one with another, face to face."[52] Also, the brother of Jared, who we know to be Mahonri Moriancumer and of whom Elder McConkie said was "scarcely a whit behind Enoch in faith and righteousness," conversed with the Lord atop a mountain's summit.[53] Later, the prophet Nephi was shown marvelous visions while on the mountain heights.[54]

"The mountains of the Lord!" McConkie poetically praised.

> *The mountains of the Great Jehovah! The holy places where the soles of his feet have trod! How grand they are! And they are the towering peaks and the cloud-topped summits where the temples of the Lord—all of them—shall be built in the last days.*
>
> *In all the days of his goodness, mountain heights have been the places chosen by the Lord to commune with his people. The experiences of Enoch, and of Moriancumer, and of Moses show how the Lord deigned to deal with his servants when they lifted themselves temporally and spiritually toward heaven's heights.*[55]

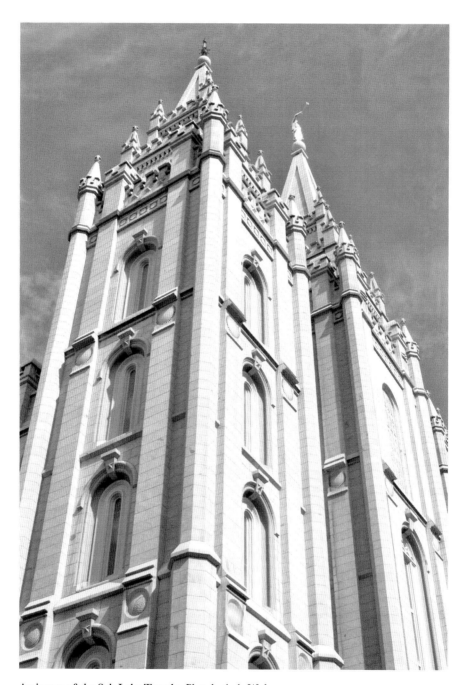

An image of the Salt Lake Temple. *Photo by Andy Weeks.*

Monuments

By all that we know of the sacred nature of temples and the ceremonies performed within them, it is suggested in holy writ that our Lord received his own endowments atop the mountain later known as Transfiguration, that holy episode in the life of our Savior when Moses and Elias appeared to pass along priesthood keys for the upbuilding of the church in time's meridian. The episode, which is described by Matthew, reads:

> *And after six days Jesus taketh Peter, James, and John his brother, and bringeth them up into an high mountain apart. And was transfigured before them: and his face did shine as the sun, and his raiment was white as the light. And behold, there appeared unto them Moses and Elias [Elijah] talking with him.*
>
> *Then answered Peter, and said unto Jesus, Lord, it is good for us to be here: if thou wilt, let us make here three tabernacles; one for thee, and one for Moses, and one for Elias.*
>
> *While he yet spake, behold, a bright cloud overshadowed them: and behold a voice out of the cloud, which said, This is my beloved Son, in whom I am well pleased; hear ye him.*
>
> *And when the disciples heard it, they fell on their face, and were sore afraid.*
>
> *And Jesus came and touched them, and said, Arise, and be not afraid. And when they had lifted up their eyes, they saw no man, save Jesus only.*[56]

The author and his wife, Heidi, stand for a photo outside the Salt Lake Temple on August 4, 1992. According to Mormon theology, temples are places where husbands and wives may be married not just until death do them part, but for eternity. Other ordinances of the gospel take place in temples, such as proxy baptism. *Photo by Andy and Heidi Weeks.*

"In the providences of the Lord the saints know some things that the world does not know about the spiritual outpouring of divine grace that fell on the Mount of Transfiguration," McConkie wrote. "But even latter-day revelation does not set forth the full account, and until men attain a higher state of spiritual understanding than they now enjoy, they will continue to see through a glass darkly and to know only in part the visionary experiences of the presiding officers of the meridian Church. That which is known, however, singles out this night as one of the most important and glorious in the lives of those who saw within the veil and who heard the voices of the heavenly participants."[57]

While perhaps not on a mountaintop, it is likely that our first parents, Adam and Eve, received their endowments while in the Garden of Eden. Among the covenants they entered into on that special day—covenants made by priesthood ordinances usually reserved for temples, covenants made in the presence of God the Father—pertained to the new and everlasting covenant of marriage.

The Tabernacle and Portable Temples

"And let them make me a sanctuary," the Lord told Moses, "that I may dwell among them. According to all that I shew thee, after the pattern of the tabernacle, and the pattern of all the instruments thereof, even so shall ye make it."[58]

The Lord then showed Moses the design of the tabernacle, how he wanted his Holy House to be built.[59] He also described the pattern of temple dress and initiated sacrificial ordinances to be performed near the tabernacle.[60]

> *And Moses took the tabernacle, and pitched it without the camp, afar off from the camp, and called it the Tabernacle of the congregation. And it came to pass, that every one which sought the Lord went out unto the tabernacle of the congregation, which was without the camp.*
>
> *And it came to pass, when Moses went out unto the tabernacle, that all the people rose up, and stood every man at his tent door, and looked after Moses, until he was gone into the tabernacle.*
>
> *And it came to pass, as Moses entered into the tabernacle, the cloudy pillar descended, and stood at the door of the tabernacle, and the LORD talked with Moses.*

> *And all the people saw the cloudy pillar stand at the tabernacle door: and all the people rose up and worshipped, every man in his tent door.*
>
> *And the LORD spake unto Moses face to face, as a man speaketh unto his friend.*[61]

Though the Lord had previously appeared in a pillar of fire atop Mount Sinai, it was in his tabernacle—a portable temple that could be moved wherever the children of Israel traveled—where he thereafter spoke with Moses "face to face." The temple, with its sacred ordinances performed by the priesthood of God, has always been reserved as the sanctuary of the Lord, the place where Jehovah would visit his people and commune with his chosen servants, the prophets. Elder Orson Pratt said that the Lord "in ancient days, when he constructed temples and tabernacles, did honor them by his presence."[62] Elder McConkie explained:

> *Once the tabernacle was prepared according to the divine plan; once this sacred sanctuary was set up as a house of the Lord; once a holy temple was again available in Israel—then Jehovah honored his word and used the sacred building and the holy place and the Holy of Holies as his own earthly house.*
>
> *To this place he came down to commune with Moses and give commandments to his people. When Moses, for instance, complained, saying, "I am not able to bear all this people alone, because it is too heavy for me," the Lord replied: "Gather unto me seventy men of the elders of Israel, whom thou knowest to be the elders of the people, and officers over them; and bring them unto the tabernacle of the congregation, that they may stand there with thee.*
>
> *And I will come down and talk with thee there: and I will take of the spirit which is upon thee, and I will put it upon them; and they shall bear the burden of the people with thee, that thou bear it not thyself alone." As was his wont, Moses hearkened to the voice of his Lord. He "went out, and told the people the word of the Lord, and gathered the seventy men of the elders of the people, and set them round about the tabernacle. And the Lord came down in a cloud, and spake unto him, and took of the spirit that was upon him, and gave it unto the seventy elders: and it came to pass, that, when the spirit rested upon them, they prophesied, and did not cease." (Num. 11.)*
>
> *Truly in that day, the Shekinah* [or divine presence] *rested in the Holy of Holies, and God was with his people.*[63]

Solomon's Temple

"As far as we know," Elder McConkie continued, "all temples in Israel from Moses to Solomon were of the portable-tabernacle type."[64] The mighty man David, who would later write psalms of praise to the Lord, made plans to build a house to the God of heaven. The Lord forbade this, however, saying, "Thou shalt not build an house unto my name, because thou hast shed much blood upon the earth in my sight."[65] Instead, the responsibility to build a house of the Lord fell upon David's son, Solomon, whom the Lord said "shall build an house for my name."[66]

The building of the temple was a monumental task, which began in the fourth year of Solomon's reign. For the setting of the temple, he chose the east side of Jerusalem atop a place called Mount Moriah, the place where his father David "had prepared in the threshing floor of Ornan the Jebusite."[67] The Lord told Solomon, "Concerning this house which thou art building, if thou wilt walk in my statutes, and execute my judgments, and keep all my commandments to walk in them; then will I perform my word with them which I spake unto David thy father: And I will dwell among the children of Israel, and will not forsake my people Israel. So Solomon built the house and finished it."[68]

The Lord said he would dwell among his people in Israel once the temple was built, and if they lived worthy of his presence. "Behold, I build an house to the name of the LORD my God, to dedicate it to him," Solomon exulted. "And the house which I build is great: for great is our God above all gods."[69]

As for the temple's construction, an area of about six hundred by three hundred feet had to be prepared. The summit of the hill, where later was built Dome of the Rock that still stands today, was both leveled and enlarged by means of retaining walls built on the sides. Stones for the temple were quarried from the mountains, with thirty thousand people working on the Lord's house.

"And king Solomon raised a levy out of all Israel; and the levy was thirty thousand men," the record states.

> *And he sent them to Lebanon, ten thousand a month by courses: a month they were in Lebanon, and two months at home: and Adoniram was over the levy.*
>
> *And Solomon had threescore and ten thousand that bare burdens, and fourscore thousand hewers in the mountains; Beside the chief of Solomon's officers which were over the work, three thousand and three hundred, which ruled over the people that wrought the work.*

Monuments

> *And the king commanded, and they brought great stones, costly stones, and hewed stones, to lay the foundation of the house.*
>
> *And Solomon's builders and Hiram's builders did hew them, and the stonesquarers: so they prepared timber and stones to build the house.*[70]

The temple was made of gold and other precious material.[71] Construction of the temple began in 959 BC and was completed seven and a half years later. Once completed, the Ark of the Covenant, which contained the stone tablets given to Moses on Sinai, was placed within the Holy of Holies. "And it came to pass, when the priests were come out of the holy place, that the cloud filled the house of the Lord, So that the priests could not stand to minister because of the cloud: for the glory of the Lord had filled the house of the Lord."[72] Solomon offered a dedicatory prayer,[73] after which the people celebrated with burnt offerings and sacrifices that were destroyed by fire from heaven, "and the glory of the LORD filled the house."[74]

The Lord later appeared to Solomon, saying: "For now I have chosen and sanctified this house, that my name may be there for ever: and mine eyes and mine heart shall be there perpetually…And this house, which is high, shall be an astonishment to every one that passeth by it."[75] So it stood on Mount Moriah until the temple's demise more than 350 years later, when the Babylonians, after conquering Israel, destroyed it in 586 BC and carried away as war trophies the sacred vessels of the temple.[76]

"The Babylonian army killed many Israelites and carried even more captive to Babylon," author Marianne Monson-Burton explains in her book *Celebrating Passover*. "As the exiles mourned for their homeland and the Lord's defiled sanctuary, they wrote hymns of sorrow recorded in the book of Psalms. 'O God, the heathen are come into thine inheritance; thy holy temple have they defiled; they have laid Jerusalem on heaps (Psalms 79:1).'"[77] Forty-eight years after its destruction, however, the Persian king Cyrus said the Israelites could return to their former land "and build the house of the Lord God of Israel."[78] Under the reign of Darius, successor to King Cyrus, the new temple was dedicated on March 12, 515 BC. But unlike Solomon's great temple, which was full of splendor and homespun glory, this new temple lacked the former temple's eloquence and was, in effect, (about ninety feet) smaller than Solomon's. The temple was, however, repaired and enlarged at various times between Zerubbabel and Herod the Great, and, more importantly, was made by the Lord's presence a "house with glory."[79]

Herod's Temple

It is perhaps ironic that one of history's greatest temples was known by the name of Herod, one of the New Testament's most vile persons. "Herod was the third ruler in an Indumean family which had been converted to the Jewish faith, and which established a semi-independent kingdom under the protection of Rome," author Duane S. Crowther has written in his book *Born to Save Mankind*. "Herod succeeded his father, Antipater…He was a great builder and instituted numerous construction projects throughout the land, including Caesarea; the Temple of Herod; the Antonia Fortress, and many other buildings at Jerusalem; several mountain fortresses including Masada and Herodian; aqueducts and other waterworks; and many other projects. His was a cruel reign; he even had his wife and three of his sons murdered. He ruled Judea from 37 to 4 B.C."

Herod began restoration of the temple in his eighteenth year of reign, about 19 BC. Though the main portions of the temple were completed before Herod's death, work was still ongoing at the time of Christ. Even while work continued—and despite who was restoring it—the temple played a vital role in the Savior's ministry and was the place wherein the angel Gabriel appeared to Zacharias and foretold the coming of John the Baptist, forerunner to the Messiah.[80]

The temple was manufactured with the finest qualities and craftsmanship then available. It was ornate, rich and complemented the times. As Monson-Burton explained: "Considered one of the wonders of the ancient world, the dazzling Temple rivaled the great Egyptian pyramids for fame. This enormous structure was faced with the whitest marble and adorned with pure gold. Set upon the highest hill in Jerusalem, this towering edifice was the crown of the holy city."

There, among its splendor, sacrifices were offered as was prescribed by the Law of Moses. These sacrifices pointed toward the coming of the Messiah and the atoning sacrifices he would make for his people.

Herod's Temple was, in very fact, the temple that Jesus knew. It was there where Mary purified herself, as all women did at that time after giving birth.[81] It was at Herod's Temple where the aged Simeon took the infant Jesus in his arms and proclaimed, "Lord, now lettest thy servant depart in peace, according to thy word. For mine eyes have seen thy salvation, Which thou hast prepared before the face of all people; A light to lighten the Gentiles, and the glory of thy people Israel."[82] It was at this same house of worship where the prophetess Anna, "who departed not from the temple, but served

God with fastings and prayers night and day," also beheld the baby Savior and, after doing so, "gave thanks likewise unto the Lord, and spake of him to all them that looked for redemption in Jerusalem."[83]

It was in this same temple where Jesus's mother, Mary, found him teaching at age twelve;[84] the temple wherein the Savior cast out money changers because they sought to make his Father's "house of prayer...a den of thieves."[85] It was amid the temple that Herod built where the Great Physician healed the lame and the sick and gave sight to the blind.[86] The temple of Herod, most glorious and beautiful of all temples, is the one in which the veil was rent at the time of the crucifixion of the Son of God.[87] It was the temple of Herod that was in so many ways the lifeblood of the city of Jerusalem and a pivotal moment in the Savior's life.

Temples in the Book of Mormon

Repeating the words of Elder McConkie, "Temples constructed before the flood of Noah were obviously destroyed in that great deluge; those built by the Jaredites and Nephites are buried in the jungles and lost in the wilderness of the Americas."[88] Many of these latter temple sites have since been recovered by modern archeological digs and explorations, all attesting to the truths already recorded in scripture—that the Nephites, descended from the "seed of Joseph,"[89] built temples in the ancient Americas.

The prophet Nephi recorded that between about 588–570 BC, his people undertook the massive project of building a temple "after the manner of the temple of Solomon save it were not built of so many precious things; for they were not to be found upon the land, wherefore, it could not be built like unto Solomon's temple."[90] Remember that Solomon's temple was built with gold and finely crafted materials, all adorned with the riches of the world.

The Nephites, new to their land, did not have that opportunity. Still, they took pride in their work. Though perhaps they did not have the same material goods as did Solomon, "the manner of the construction [of their temple] was like unto the temple of Solomon; and the workmanship thereof was exceedingly fine."[91]

Like the people in Israel from whence the Nephites came, the temple they constructed became the center of religious activity among these early inhabitants of the Americas. Nephi's brother Jacob recorded that he taught "in the temple, having first obtained mine errand from the Lord."[92] This, he explained, because "I, Jacob, and my brother Joseph had been consecrated

priests and teachers of this people, by the hand of Nephi. And we did magnify our office unto the Lord, taking upon us the responsibility, answering the sins of the people upon our own heads if we did not teach them the word of God with all diligence; wherefore, by laboring with our might their blood might not come upon our garments; otherwise their blood would come upon our garments, and we would not be found spotless at the last day."[93]

Later, Mosiah instructed the Nephites "to go up to the temple to hear the words which his father [King Benjamin] should speak unto them."[94] We assume that there was more than one temple among the Nephites. The Book of Mormon says, "And Alma and Amulek went forth preaching repentance to the people in their temples, and in their sanctuaries, and also in their synagogues, which were built after the manner of the Jews."[95]

It is also noted that the Lamanites had built temples, though we may only assume for what purpose, as the majority of their history records that they were an idolatrous and wicked people, quick to do evil.[96] Yet their temples became a teaching avenue for the Nephite missionaries.

> *Behold, now it came to pass that the king of the Lamanites sent a proclamation among all his people, that they should not lay their hands on Ammon, or Aaron, or Omner, or Himni, nor either of their brethren who should go forth preaching the word of God, in whatsoever place they should be, in any part of their land. Yea, he sent a decree among them, that they should not lay their hands on them to bind them, or to cast them into prison; neither should they spit upon them, nor smite them, nor cast them out of their synagogues, nor scourge them; neither should they cast stones at them, but they should have free access to their houses, and also their temples, and their sanctuaries.*[97]

Still another episode among Lehi's seed is that of a much later Nephi who was given power to "rend the temple."[98] Temples played such a crucial role in the religious life of the Nephites that it was there where the righteous gathered at the crucifixion of Christ and where he appeared to them shortly thereafter.

> *And now it came to pass that there were a great multitude gathered together, of the people of Nephi, round about the temple which was in the land Bountiful; and they were marveling and wondering one with another, and were showing one to another the great and marvelous change which had taken place.*
>
> *And they were also conversing about this Jesus Christ, of whom the sign had been given concerning his death.*

And it came to pass that while they were thus conversing one with another, they heard a voice as if it came out of heaven; and they cast their eyes round about, for they understood not the voice which they heard; and it was not a harsh voice, neither was it a loud voice; nevertheless, and notwithstanding it being a small voice it did pierce them that did hear to the center, insomuch that there was no part of their frame that it did not cause to quake; yea, it did pierce them to the very soul, and did cause their hearts to burn.

And it came to pass that again they heard the voice, and they understood it not.

And again the third time they did hear the voice, and did open their ears to hear it; and their eyes were towards the sound thereof; and they did look steadfastly towards heaven, from whence the sound came.

And behold, the third time they did understand the voice which they heard; and it said unto them:

Behold, my Beloved Son, in whom I am well pleased, in whom I have glorified my name—hear ye him.

And it came to pass, as they understood they cast their eyes up again towards heaven; and behold, they saw a Man descending out of heaven; and he was clothed in a white robe; and he came down and stood in the midst of them; and the eyes of the whole multitude were turned upon him, and they durst not open their mouths, even one to another, and wist not what it meant, for they thought it was an angel that had appeared unto them.

And it came to pass that he stretched forth his hand and spake unto the people, saying:

Behold, I am Jesus Christ, whom the prophets testified shall come into the world.

And behold, I am the light and the life of the world; and I have drunk out of that bitter cup which the Father hath given me, and have glorified the Father in taking upon me the sins of the world, in which I have suffered the will of the Father in all things from the beginning.[99]

The Nephite temple played a central role in the pinnacle event of the sacred record known as the Book of Mormon, for it was there where Christ appeared to the Nephites as they were "gathered together…round about the temple." If Christ visits the earth, which as Elder McConkie explained, "he does more frequently than is supposed,"[100] temples are his venue; they are the places he visits first and foremost. So attest the biblical record and Book of Mormon. And so confirms the work of Latter-day Saint temples.

TEMPLES AS SPIRITUAL MONUMENTS

To the faithful Mormon, temples are sacred edifices where the pinnacle of worship is achieved. Through temple ordinances revealed to the Prophet Joseph Smith, and administered by priesthood authority, husbands and wives are sealed together not just for time but, if they remain faithful to their covenants, for all eternity. By the same union, their children are eternally theirs. Parents and children and grandchildren and so forth sealed together through the generations thus form one big family in the hereafter.

Outside of the church, temples often spark controversy. Many wonder and speculate about what goes on inside. Baptism for the dead, a popular ordinance officiated in modern-day temples, raises the ire of many so-called Christians who call such an act blasphemy at best and devilish at worst. To the devout Latter-day Saint, however, temples are not secret establishments but sacred buildings like Solomon's Temple.

As for proxy baptism for deceased persons who never heard of or had the opportunity to accept Jesus Christ or his gospel in the flesh, it was the Apostle Paul, who, speaking to the Corinthian saints, said, "Else what shall they do that are baptized for the dead, if the dead rise not at all? Why are they then baptized for the dead?"[101] In essence, Paul was saying that this was a true principle and that the resurrection is real. This knowledge, lost among apostate Christendom, was revealed in the latter days as part of "restitution of all things."

On or near every Mormon temple is the inscription: "Holiness to the Lord, the House of the Lord," affirming how church members view their

temples. They verily believe that such edifices, specially dedicated to the Most High, are houses of the Lord, sacred sanctuaries where his spirit and, at his will, his physical presence may be known.

Following are several spiritual experiences that took place in Utah's early temples.

Miracle at St. George

The first temple to be completed in Utah was the St. George Temple, a white monolith that stands amid the red rock of southern Utah. Dedicated on April 6–8, 1877, by Daniel H. Wells, it is the first operating temple in the church and, according to LDS history, has some remarkable spiritual episodes that happened within it.

Wilford Woodruff, third president of the church who conducted a private site dedication on January 1, 1877, claimed that on August 21, 1877, George Washington, Thomas Jefferson and other early American patriots visited him while he was inside the St. George Temple. According to Woodruff, these spirits wanted to know why the church had not yet done proxy baptism for them. The twenty-six-volume *Journal of Discourses*, which contains hundreds of sermons and other teachings from early church leaders, shares Woodruff's testimony:

> *I will here say, before closing, that two weeks before I left St. George, the spirits of the dead gathered around me, wanting to know why we did not redeem them. Said they, "Have you had the use of the Endowment House for a number of years, and yet nothing has ever been done for us. We laid the foundation of the government you now enjoy, and we never apostatized from it, but we remained true to it and were faithful to God." These were the signers of the Declaration of Independence, and they waited on me for two days and two nights. I thought it very singular, that notwithstanding so much work had been done, and yet nothing had been done for them. The thought never entered my heart, from the fact, I suppose, that heretofore our minds were reaching after our more immediate friends and relatives. I straightway went into the baptismal font* [in the temple] *and called upon brother* [John] *McCallister to baptize me for the signers of the Declaration of Independence, and fifty other eminent men, making one hundred in all, including John Wesley, Columbus, and others.*[102]

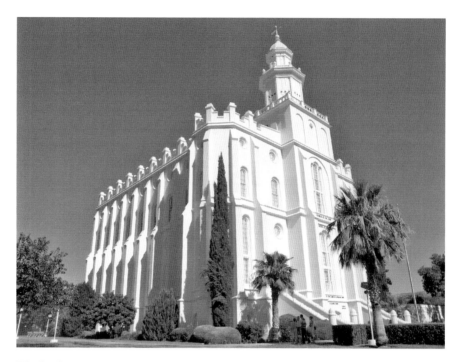

The St. George Utah Temple of The Church of Jesus Christ of Latter-day Saints. *Wikimedia commons.*

"It was a very interesting day," Woodruff wrote in his journal on that date. "I felt thankful that we had the privilege and the power to administer for the worthy dead, especially for the signers of the Declaration of Independence, that inasmuch as they laid the foundation of our government, that we could do as much for them as they had done for us."

TRIAL IN LOGAN

The Logan Temple, dedicated on May 17–19, 1884, by John Taylor, is the second such edifice to be built in Utah and is perhaps most unique among the church's temples with regard to supernatural occurrences. Such experiences from both the light and the dark worlds have been witnessed at this house of glory. According to one story about the Logan Temple, and as recorded in *The Logan Temple: The First 100 Years*, Satan at one time tried to attack the sacred edifice:

Monuments

Logan Temple President Marriner W. Merrill was sitting in his office one morning in the early 1890's when he heard a commotion outside. Stepping to the window, he saw a great congregation of people coming up the temple hill, some on foot, and others on horseback and in carriages. President Merrill's first thought was, "What will we do with so many people? If we fill every room in the temple, it will not begin to hold them all."

The riders tied their horses up at the hitching posts or turned them loose on the temple corrals, and walked complacently about the front grounds, without seeming to have much purpose in mind. They were rather an odd looking group, and were dressed quite shabbily.

They made no effort to enter the temple, so President Merrill went out to greet them and see what he could do for the group. He said to their leader: "Who are you, and who are these people who have taken possession of the temple grounds unannounced?"

He answered: "I am Satan, and these are my people." Brother Merrill asked: "What do you want, and why have you come here?" Satan replied: "I don't like what is being done in the Logan Temple and have come to stop it." That was a bit of a shock to President Merrill, and he answered: "No,

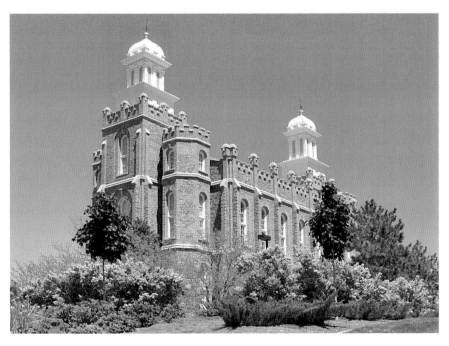

The Logan Utah Temple of The Church of Jesus Christ of Latter-day Saints. *Photo by Cory Maylett.*

we will not stop it. This is the work of the Lord and must go on. You know that you or any one else can not stop the work of the Lord."

"If you refuse to stop it, I will tell you what I propose to do," the adversary said. "I will scatter this congregation of people throughout these valleys, and we will keep people from coming to the temple. We will whisper in their ears and discourage them from attending the temple. This will stop your temple work."

President Merrill then used the power of his priesthood and commanded Satan and his followers to depart from holy ground. He said that within four or five minutes there was not a person, horse or buggy in sight. They just disappeared into thin air and were gone.[103]

MORONI AT MANTI

One of the stories in Mormon folktale says that Moroni, last of the Book of Mormon prophets, visited the area of present-day Manti during his sojourn across the country after the terrible battle at Cumorah in about AD 421. The story is attributed to Brigham Young, who announced on June 25, 1875,

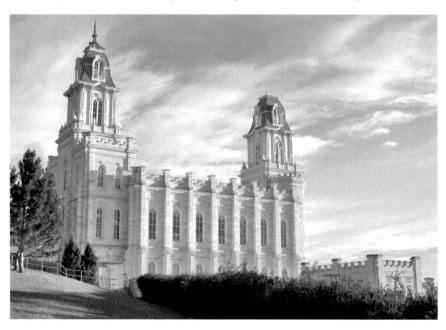

The Manti Utah Temple of The Church of Jesus Christ of Latter-day Saints. *Wikimedia commons.*

Monuments

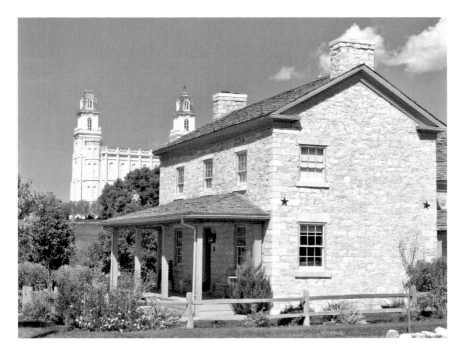

A historic Manti home with the Manti Utah Temple in the background. Manti was the first community to be settled outside the Wasatch Front and served as the hub for the formation of many other communities in central Utah. The Manti Utah Temple, the third temple built by The Church of Jesus Christ of Latter-day Saints, dominates the area's skyline. Manti annually hosts the two-week-long Mormon Miracle Pageant. *Photo by Ken Lund, Creative Commons Attribution-ShareAlike 2.0.*

that a temple would be built on the hill where the temple now stands. Two years later, on April 25, 1877, he officially dedicated the site. Leading church member Warren S. Snow to the southeast corner of the chosen location, Young said, "Here is the spot where the Prophet Moroni stood and dedicated this piece of land for a Temple, and that is the reason why the location is made here, and we can't move it from this spot."[104]

Dedication of the building was held between May 21 and 23, 1888, with Lorenzo Snow acting as voice. In 1928, lightning struck the east tower of the temple, causing a fire that burned for three hours before it was extinguished.

"In 1985, the Manti Utah Temple was formally rededicated following a four-year renovation project that included updating the auxiliary systems of the temple; adding three sealing rooms, new dressing rooms, a nursery, and offices; and restoring the pioneer craftsmanship and artwork to their former glory. The three-day open house was attended by 40,308 visitors," reads an entry on the church's temple website.

Something else unique about this temple site: It is the place where every summer the Mormon Miracle Pageant is held. Actors dress in period clothing and, on the green grass of the temple hill, reenact the drama of the Book of Mormon, First Vision, Restoration and the pioneer crossing to the West. It is a joyful, touching experience and a memorable way to spend a summer eve under the stars.

TABERNACLE TURNED TEMPLE

President Joseph F. Smith, at the dedication of the Uintah Stake Tabernacle on August 24, 1907, said he "would not be surprised if the day would come when a temple would be built in your own midst here."[105]

His words proved prophetic some ninety years later, when in November 1997 the Vernal Utah Temple was dedicated by President Gordon B. Hinckley. The old tabernacle, which was the site of many church and community functions over the decades, was itself turned into a modern House of the Lord. It was the tenth temple built in Utah and the first temple built from an existing building. "A modern temple was built within the shell of the gutted tabernacle, which had fallen into serious disrepair and had not hosted a stake conference since 1983," reads an entry on LDS.org.

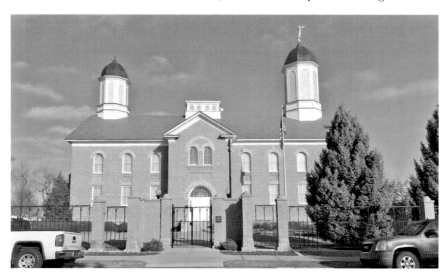

The Vernal Utah Temple was first constructed as a church tabernacle in 1907. Ninety years later, in 1997, it was dedicated as a temple. *Photo by Andy Weeks.*

"The idea of converting the Uintah Stake Tabernacle into the Vernal Utah Temple was first proposed by leaders of the Vernal Utah Glines Stake to area authorities in 1984, but the proposal was eventually rejected by the First Presidency," the website reads. "Many other possibilities were pursued, and the building had even been put up for sale for a time. However, in 1993, the idea of a temple was proposed again. This time, it met with First Presidency approval."

Before it closed as a tabernacle, more than 18,000 visitors toured the site, bespeaking the influence it had on the community over the years. Later, when it opened for public house before its dedication as a temple, the site received some 118,700 visitors.

A couple interesting items about this tabernacle-turned-temple: "All of the furniture and fixtures salvaged from the Uintah Stake Tabernacle were sold at public auction on April 15, 1995. Everything available sold in 3½ hours." And, "The old dome of the Uintah Stake Tabernacle was removed and renovated into a gazebo, located at the Ashley Valley Community Park. The Vernal Utah Temple was given two domes instead of one, as was featured on the tabernacle."

Jordan River Temple

At the time this temple was announced on February 3, 1978, half the endowments performed in the church took place in three of the then sixteen operating temples: in Salt Lake, Ogden and Provo. Groundbreaking took place on June 9 the following year, with a month-long open house from September 29 to October 31, 1981. Between November 16 and 20, Marion G. Romney, a counselor in the First Presidency, dedicated the building. It was Utah's seventh operating temple.

"At the unconventional groundbreaking ceremony of the Jordan River Utah Temple, President Spencer W. Kimball delivered his address, offered the dedicatory prayer, and then mounted a huge Caterpillar tractor. He put into action his oft-quoted admonishment to 'lengthen our stride' by operating the controls to move a giant shovelful of dirt."[106]

Hours before the dedication of the temple, news correspondents announced that President Kimball, "who was recovering from surgery and a lengthy hospital stay, would likely be confined to his room at the Hotel Utah during the dedication services. But with tears of joy, he was welcomed to the Celestial Room just before the ceremony commenced."[107]

A History of Mormon Landmarks in Utah

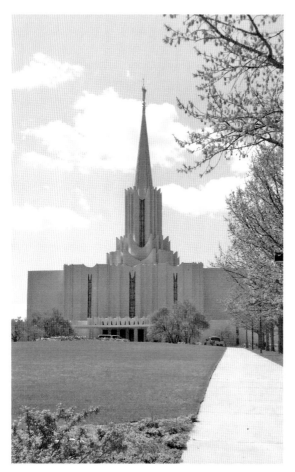

Left: The Jordan River Temple, dedicated in 1981, was the temple President Ezra Taft Benson, thirteenth prophet of the church, used every week during the final years of his life. It was the seventh temple built in Utah. *Photo by Andy Weeks.*

Below: On all temple grounds, gardens and lawns are neatly kept. Here, flowers bloom outside the walls of the Jordan River Temple. *Photo by Andy Weeks.*

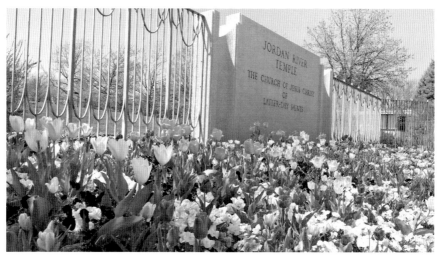

Monuments

During the later years of Ezra Taft Benson's administration, President Benson, thirteenth president of the church, visited this sacred edifice every Thursday because it was easier for the aging prophet to participate in the work here with its one-room endowment sessions rather than moving from room to room as at the Salt Lake Temple, where most other church leaders participated in weekly temple sessions.

Other Utah temples as of this writing include:

OGDEN UTAH TEMPLE, announced on August 24, 1967, and dedicated on January 18, 1972. It was remodeled and later rededicated on September 21, 2014.

PROVO UTAH TEMPLE, announced on August 14, 1967, and dedicated on February 9, 1972.

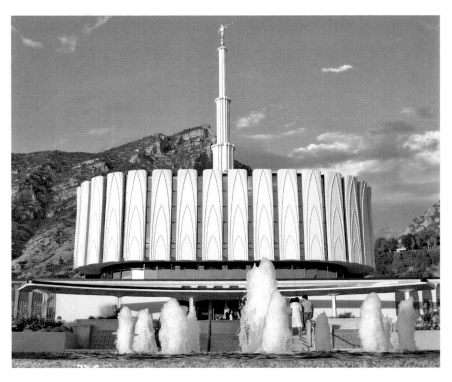

The Provo Utah Temple of The Church of Jesus Christ of Latter-day Saints. *Wikimedia commons.*

BOUNTIFUL UTAH TEMPLE, announced on February 2, 1990, and dedicated on January 8, 1995.

A History of Mormon Landmarks in Utah

Mount Timpanogos Temple, announced on October 3, 1992, and dedicated on October 13, 1996.

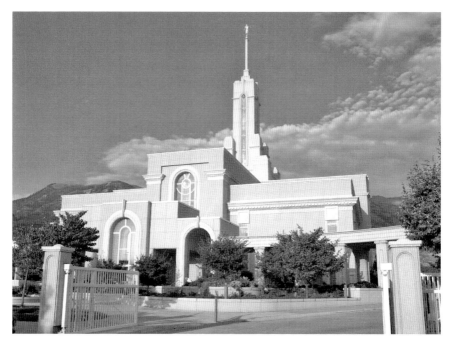

The Mount Timpanogos Utah Temple of The Church of Jesus Christ of Latter-day Saints. *Wikimedia commons.*

Draper Utah Temple, announced on October 2, 2004, and dedicated on March 9, 2009.

Oquirrh Mountain Temple, announced on October 1, 2005, and dedicated on August 21, 2009.

Brigham City Temple, announced on October 3, 2009, and dedicated on September 23, 2012.

Payson Utah Temple, announced on January 25, 2010, and dedicated on June 7, 2015.

Provo City Center Temple, announced on October 1, 2011, and slated for dedication on March 20, 2016.

TEMPLE TOPPER: ANGEL MORONI

Atop nearly all Latter-day Saint temples, minus eight, is a gold-plated statue of an angel, a trumpet held to his lips. In some versions, he grasps a book to his chest. The statue, with or without a book, is symbolic of John's apocryphal vision, when he wrote, "And I saw another angle fly in the midst of heaven, having the everlasting gospel to preach unto them that dwell on the earth, and to every nation, and kindred, and tongue, and people, Saying with a loud voice, Fear God, and give glory to him; for the hour of his judgment is come: and worship him that made heaven, and earth, and the sea, and the fountains of waters."[108]

Mormons know this angel by name: Moroni.

To the Latter-day Saints, Moroni is more than a statue or even an angel. In mortality, some 1,600 years ago, Moroni was a prophet who lived on the American continent. He was keeper of the gold plates, which he eventually buried to keep safe from apostate groups but that in the latter days came into Joseph Smith's possession. It was this same Moroni, later sent as a heavenly messenger, who delivered the plates to Joseph who then, by the gift and power of God, translated them into the English language. The result was the Book of Mormon.

The Book of Mormon begins 600 years before Christ in Jerusalem and ends some 421 years after Christ in the New World. It is a record of immigrants who came to the Americas, at the Lord's direction, and grew into mighty civilizations—Jaredites, Nephites and Lamanites—before their eventual demise because of wickedness and war.

What exactly is the message of the Book of Mormon?

In short, it is as its subtitle suggests: Another Testament of Jesus Christ. While detailing the rise and fall of the ancient inhabitants of the Americas, its primary purpose is to support the Holy Bible in the testimony that Jesus is the Christ, the Son of God and Savior of humankind. "In its more than 6,000 verses, the Book of Mormon refers to Jesus Christ almost 4,000 times and by 100 different names: 'Jehovah,' 'Immanuel,' 'Holy Messiah,' 'Lamb of God,' 'Redeemer of Israel,' and so on," reads an entry on the LDS website. The book was written by many ancient prophets by the spirit of prophecy and revelation. "Their words, written on gold plates, were quoted and abridged by a prophet-historian named Mormon." The introduction to the book itself explains:

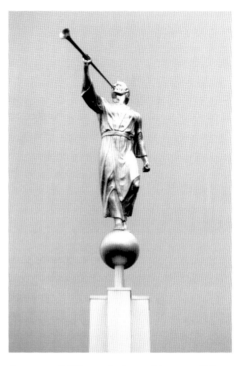

Atop most LDS temples is a gold statue of the Angel Moroni. Moroni, a prominent figure in Book of Mormon history, is depicted holding a trumpet to his mouth, symbolic of the apostle John's writing that in the latter days the gospel of Jesus Christ would be heralded to the world. This statue of Moroni on a temple in Bern, Switzerland, is nearly identical to the statue atop the Center Spire of the Salt Lake Temple. *Public domain.*

The crowning event recorded in the Book of Mormon is the personal ministry of the Lord Jesus Christ among the Nephites soon after his resurrection. It puts forth the doctrines of the gospel, outlines the plan of salvation, and tells men what they must do to gain peace in this life and eternal salvation in the life to come.

In due course the plates were delivered to Joseph Smith, who translated them by the gift and power of God. The record is now published in many languages as a new and additional witness that Jesus Christ is the Son of the living God and that all who will come unto him and obey the laws and ordinances of his gospel may be saved.

Moroni then, last of the book's historians and prophets, who revealed the plates to Joseph Smith as part of the restoration, fulfilled another role: in the Latter-day Saint view, he became that angel whom John saw in vision, heralding the gospel of a new dispensation before the Second Coming of Jesus Christ.

In essence, that is why gold statues of Moroni stand atop LDS temples. Most of them face east—the direction that Christ is said to make his appearance when he returns to the earth.

WHERE PROPHETS AND PAUPERS REST

Salt Lake City Cemetery

The Salt Lake City Cemetery, spread over 120 acres on a hilltop in the avenues between N and U Streets and Fourth Avenue and Wasatch Boulevard, looks over the valley below and to the Oquirrh Mountains to the west. It is a beautiful view of the Great Basin. Turn around and a different scenery presents itself: hundreds of tombstones—some of them flat, most of them standing—decorate the tree-lined grounds. It is sacred, hallowed ground—a place where prophets and paupers lie in rest.

Grave dates stretch back to September 27, 1847, when Mary B. Wallace, a young child, was interred at the site, according to the Salt Lake City webpage about the cemetery. Two years later, Brigham Young sought pleasant burial grounds the Latter-day Saints could use and appointed three men, including George Wallace (young Mary's father), to find such a place. He led the other men to his daughter's grave and where, by this time, other family members had been buried. The men liked the location and suggested it to President Young. Later, Young asked that twenty acres be surveyed as burial grounds for deceased church members. Once the General Assembly of the State of Deseret incorporated Great Salt Lake City in 1851, a city council thereafter officially organized the city cemetery, and just five years later, in 1856, Jedediah M. Grand pitched for the creation of an ordinance that allowed people of all faiths to be buried in the cemetery, not on private

MONUMENTS

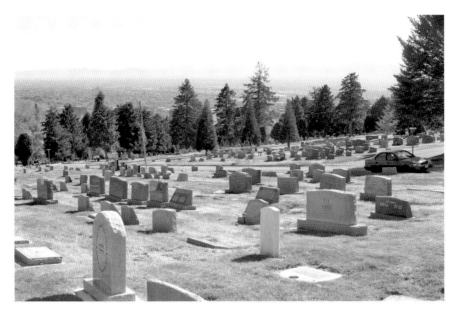

A view of Salt Lake City Cemetery, located in Salt Lake City's avenue district, and the valley below. *Photo by Andy Weeks.*

property. Before long, non-LDS members also started being interred. As of July 2015, according to the cemetery's website, more than 124,000 bodies have been buried in these hallowed grounds.[109]

Taking a casual tour of the site will expose you to some of the more famous names in LDS history. Many of them are engraved on tall, oversized markers honoring the deceased; some of the headstones are flat emblems of honor. Nearly all former church presidents are interred here, as are many other general authorities: Gordon B. Hinckley, Howard W. Hunter, Spencer W. Kimball, Harold B. Lee and David O. McKay, to name a few of the presidents. Apostles such as Bruce R. McConkie and Henry B. Moyle are some of the other names recognizable in LDS history. Among many others, their grave sites are still decorated with flowers by family and even church members who, out of respect for the Lord's anointed, come here to honor the deceased.

In the midst of headstones, not far from other church leaders' graves, stands a tall cement monument that honors Hyrum Smith, brother of the prophet Joseph, whose body is not here but lies buried in Illinois. Originally, Hyrum and his brother-prophet were buried in the Nauvoo city cemetery. Or so people thought. What really happened was that bags of stone were

A History of Mormon Landmarks in Utah

 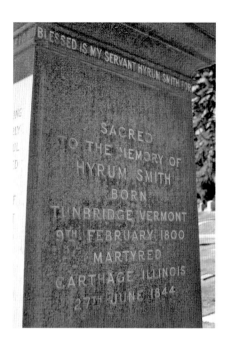

Left: A monument honoring Hyrum Smith, brother of the Prophet Joseph Smith, at the Salt Lake City Cemetery. *Photo by Andy Weeks.*

Right: Part of the inscription on the Hyrum Smith memorial at Salt Lake City Cemetery. Hyrum Smith was brother of the prophet Joseph; both were killed by a mob while jailed on false charges at Carthage, Illinois, on June 27, 1844. *Photo by Andy Weeks.*

A towering grave marker honoring David O. McKay, ninth president of The Church of Jesus Christ of Latter-day Saints, at Salt Lake City Cemetery. *Photo by Andy Weeks.*

Monuments

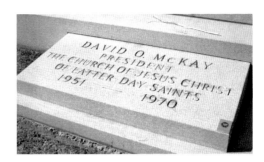

Grave marker of President David O. McKay at Salt Lake City Cemetery. *Photo by Andy Weeks.*

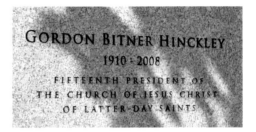

Grave marker of Gordon B. Hinckley, fifteenth president and prophet of The Church of Jesus Christ of Latter-day Saints. Hinckley is buried at Salt Lake City Cemetery, where many other church presidents and other leaders are interred. *Photo by Andy Weeks.*

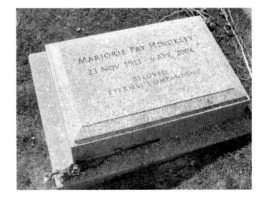

Grave marker of Marjorie Pay Hinckley, situated next to her husband's, Gordon B. Hinckley, in Salt Lake. *Photo by Andy Weeks.*

Bruce R. McConkie, latter-day apostle, was one of the LDS church's most prolific and doctrinal savvy leaders. He wrote numerous books on LDS theology, including the encyclopedic volume *Mormon Doctrine* and the six-book set on the life of Christ, The Messiah Series, among other works. His grave marker is a simple one, attesting to the humble man he was despite his popularity in LDS circles. *Photo by Andy Weeks.*

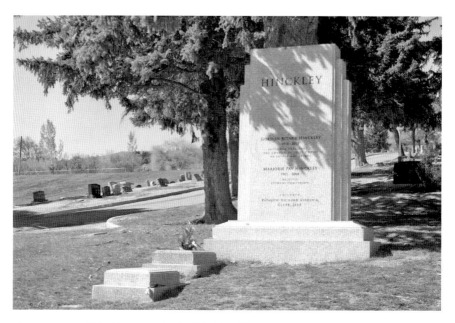

Grave marker of President Gordon B. Hinckley. *Photo by Andy Weeks.*

placed in the coffins before they were buried, while the bodies of the two brethren were hidden away to a then a secret location. An 1857 article in the *Deseret News* reads:

> *The coffins were then taken out of the boxes into the little bedroom in the northeast corner of the Mansion, and there concealed and the door locked. Bags of sand were then placed in each end of the boxes, which were then nailed up, and a mock funeral took place, and the boxes deposited in a grave with the usual ceremonies.*
>
> *This was done to prevent the enemies of the martyred prophet and patriarch getting possession of the bodies, as they had threatened they would do.*
>
> *About midnight the coffins containing the bodies were taken through the garden, around by the pump and were conveyed to the Nauvoo House, and buried in the basement story.*
>
> *After the bodies were interred, and the ground smoothed off, a most terrific shower of rain, accompanied by thunder and lightning, occurred and obliterated all traces of the fact that the earth had been newly dug.*
>
> *The bodies remained in the cellar of the house until fall, when they were*

removed to a point near the Mansion and buried side by side. The Bee House was then moved and placed over their graves.[110]

Later, in January 1928, the Reorganized Church of Jesus Christ of Latter Day Saints (which has no affiliation with The Church of Jesus Christ of Latter-day Saints and now is called the Community of Christ) removed the remains and placed them in marked graves on the original Nauvoo property of Joseph Smith, along with his first wife, Emma. Far removed over thousands of miles of prairie land and mountains lay many other church leaders in the Great Basin of Utah. For those who have never visited the first church president's grave site in Nauvoo, Illinois, visiting the Salt Lake City Cemetery is another way they can pay tribute to the founder of Mormonism because of the many other burial sites of church leaders that lie here. There's also an angel at the Salt Lake City Cemetery dedicated to the memory of children, thus making this cemetery not only a place of burial but a place truly of remembrance and reverence, a place where in the shade of a thick tree while overlooking the valley below people may say a prayer and give homage to the Lord's prophets or the princely poor.

PIONEER MEMORIAL PARK

In a quiet garden nook that almost seems out of place amid the housing development that surrounds it sits a quiet little park that honors people from Utah's pioneer past. Named Mormon Pioneer Memorial Park, but unofficially known as the Brigham Young family cemetery, statues and other memorials decorate the pretty grounds, each honoring a Mormon pioneer. Some of them are well known in LDS history, such as Eliza R. Snow, while other names may not be as recognizable to the lay body of the church. The ground's most famous occupant is Brigham Young, whose body lies interred at the park. A wrought-iron fence surrounds the holy spot, and many people who visit the memorial park today place flowers on his grave. An inscriptive plaque erected on June 10, 1938, by the Utah Pioneer Trails and Landmarks Association, after highlighting President Young's life and leadership, tells, "This tablet was erected in honor of their beloved leader by the Young Men's and Young Women's Mutual Improvement Association, which were ordained under his direction."

It wasn't until the anniversary of Young's 173rd birthday, June 1, 1974, that the park was dedicated to the honor of Mormon pioneers. Improvements to the park were completed in 2000.

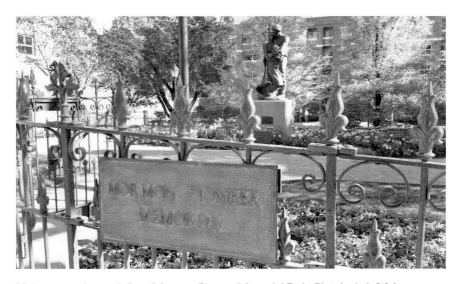

Visitors are welcome daily at Mormon Pioneer Memorial Park. *Photo by Andy Weeks.*

Brigham Young, second president of the Mormon Church, is interred at the park. His grave, as shown here, is protected by a wrought-iron fence and cement slabs. *Photo by Andy Weeks.*

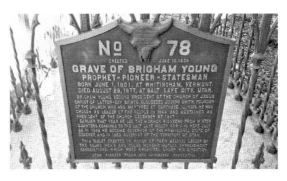

Brother Brigham and Family

A touching monument at the memorial park is a sculptor's rendition of Brother Brigham sitting on a bench reading to a couple of children. We assume they are his grandkids or, considering the many offspring he fathered through plural marriage, perhaps his own children. The emblem gives a more personal look at Brigham's life other than the sometimes fiery testator that many think of him. While Brigham could be bold and unequivocal in his pulpit preaching, he nonetheless was a compassionate and honest man who loved his family, the Prophet Joseph Smith and Mormonism and its great cause. Some of his teachings about parenting:

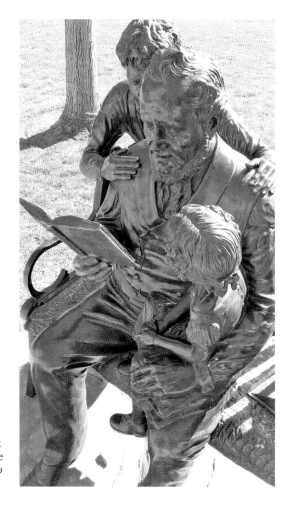

A sculpture of Brigham Young at Pioneer Memorial Park shows the prophet reading to children. *Photo by Andy Weeks.*

> *We are the guardians of our children; their training and education are committed to our care, and if we do not ourselves pursue a course which will save them from the influence of evil, when we are weighed in the balance we shall be found wanting.*
>
> *Let parents treat their children as they themselves would wish to be treated, and set an example before them that is worthy of you as Saints of God.*
>
> *Bring up your children in the love and fear of the Lord; study their dispositions and their temperaments, and deal with them accordingly, never allowing yourself to correct them in the heat of passion; teach them to love you rather than to fear you.*[111]

Young family members lie interred next to their prophet and head of household, Brigham Young. *Photo by Andy Weeks.*

Several of Young's family members, wives and children, are interred at this serene cemetery-park. Young family members buried at the park include Mary Ann Angell Young, Joseph Angell Young, Alice Young Clawson, Lucy Ann Decker and Mary Van Cott Young.

One of the more famous Young family members, well-known in LDS history and literature, first had ties to the Prophet Joseph Smith. She was the sister of later church president Lorenzo Snow and polygamous wife to both Brother Joseph and, after his passing, Brother Brigham—though you know her as Sister Snow.

Eliza R. Snow

One of the tenets of Mormonism, a family-oriented religion, is that all humankind is the offspring of a loving Heavenly Father. Jesus Christ, according to LDS teachings, is the Father's firstborn in the spirit and His only begotten son in the flesh. These two holy beings, plus the Holy Ghost, make up the Godhead, or what other religions may call the Trinity. In LDS doctrine, however, God the Father and Jesus the Son are physical beings, while the Holy Ghost is a personage of spirit. All are three separate and distinct beings but with one common purpose that makes them seem as one: "to bring to pass the immortality and eternal life of man."[112]

If God is the creator of our spirits, and we are fashioned in his likeness, where does womanhood come into play? For that matter, did the Father create spiritual beings on his own, without the help of an eternal helpmate, or was Adam's way but a pattern of how it's always been done, even in the spirit?

According to LDS teachings, the mortal family is not unlike the family found in heaven. Just as we have a Heavenly Father, so we also have a Heavenly Mother. The doctrine, not readily talked about in lay conversations, was pronounced by Joseph Smith as early as 1839.

In 1909, the First Presidency issued a statement on the origin of man, explaining that "man, as a spirit, was begotten and born of heavenly parents, and reared to maturity in the eternal mansions of the Father" and that he is the "offspring of celestial marriage…literally the sons and daughters of Deity."[113]

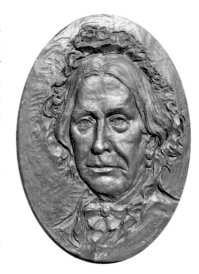

A bronze image of LDS poet Eliza R. Snow. Photo by Andy Weeks.

It was Eliza Roxy Snow, however, who dramatized the doctrine in song. Snow, a devout woman and promoter of women's worth, wrote many poems during her time, some of them becoming LDS hymns. Her most famous was one called "O My Father." In part, it reads:

> *I had learned to call thee Father,*
> *Thru thy Spirit from on high,*
> *But, until the key of knowledge*
> *Was restored, I knew not why.*
> *In the heav'ns are parents single?*
> *No, the thought makes reason stare!*
> *Truth is reason; truth eternal*
> *Tells me I've a mother there.*

A monument at Mormon Pioneer Memorial Park is dedicated to Eliza R. Snow. One of its icons is a bronze plaque with words and music notes of the famous hymn. Another bronze emblem is a picture of Snow, donned in a pioneer bonnet, something she readily wore, according to the historical images of her found today.

Eliza R. Snow is a unique figure in LDS history in that she is one of few women recognized for her contributions. She was a polygamous wife to Joseph Smith (and later Brigham Young) and, among other church callings, served as the second president of the Relief Society, the church's all-women organization.

Sister Snow immigrated to Utah Territory and passed away on December 5, 1887, in Salt Lake City. She left something behind—something reverent and literary and wonderful: some five hundred poems, including her best known mentioned above. It is not unlikely that every Sunday, somewhere in the world, an LDS congregation sings the hymn and is touched by its powerful, sublime message: humankind is of divine heritage, and salvation is a family affair.

William Clayton

Perhaps no church hymn dramatizes the pioneer spirit as much as William Clayton's "Come, Come, Ye Saints." Though not buried here, Clayton and his hymn, composed in April 1846 while camped near Locust Creek, Iowa, are honored at the memorial park.

Come, come, ye Saints, no toil nor labor fear;
But with joy, wend your way.
Though hard to you this journey may appear,
Grace shall be as your day

The hymn is sung even today in congregations throughout the world, its melodious tune and message inspiring a whole new generation of Latter-day Saints, which in some cases refer to themselves as modern-day pioneers. Pioneers today are confronted with challenges that former-day pioneers did not face: widespread crime, online pornography, persuasive educational and moral issues and much more. Pioneers focus on their goals, plow through difficult challenges and come out on top. And they leave a legacy for the younger generation. Such was the case with the early pioneers, and such is the case with today's true pioneers.

William Clayton was a true pioneer.

Clayton was born on July 17, 1814, in Penwortham, Lancashire, England, and was baptized into Mormonism on October 21, 1837. Three years later, he led a group of British converts to the United States to join the Latter-day

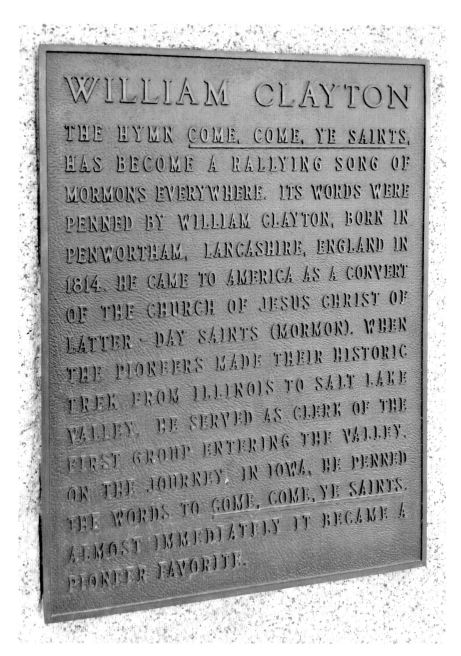

A bronze replica of Clayton's famous hymn "Come, Come, Ye Saints." *Photo by Andy Weeks.*

Saints in their Zion. So impressed was he meeting the Prophet Joseph that Clayton took time to describe the encounter, writing:

> *We have had the privilege of conversing with Joseph Smith Jr. and we are delighted with his company. We have had a privilege of ascertaining in a great measure from whence all the evil reports have arisen and hitherto have every reason to believe him innocent. He is not an idiot, but a man of sound judgment, and possessed of abundance of intelligence and whilst you listen to his conversation you receive intelligence which expands your mind and causes your heart to rejoice. He is very familiar, and delights to instruct the poor saints. I can converse with him just as easy as I can with you, and with regard to being willing to communicate instruction he says, "I receive it freely and I will give it freely." He is willing to answer any question I have put to him and is pleased when we ask him questions.*[114]

There are more writings, of course; many more—from casual journal entries to more descriptive ones to meeting minutes and experiences with the Prophet and other church leaders. And, of course, he also wrote poetry.

Clayton was a clerk under Joseph Smith, charged with keeping detailed records of the growing religion. He faithfully fulfilled his duties, leaving us a remarkable transaction of Mormonism's earliest days. As church historian James B. Allen has written, "if not for Clayton and many people like him, we would have practically no recorded history of the early church."

Clayton was true to his newfound faith, even when the principle of polygamy was initiated by Joseph Smith. He wound up marrying nine wives and fathered forty-two children. In 1846, he left Nauvoo with the first Latter-day Saint group that headed west, and once in the Salt Lake Valley published *The Latter-day Saints' Emigrants' Guide*, aimed to help other pioneers on their journey from Winter Quarters, Nebraska—where the emigrants camped during the winter of 1846–47—to the Rocky Mountains. He also continued to maintain church records, pursue business ventures and become an auditor for Utah Territory, among other responsibilities.

Besides his famous hymn—others of his poems also were set to music—Clayton is credited as having developed a version of the modern odometer. When he and Apostle Orson Pratt were assigned to record the number of miles the company traveled each day, he ponderously thought of how best to do this. His solution: tying a red flag onto one of the wagon wheels and counting the revolutions. At the end of a day, to know how far the company had traveled, he would multiply the total count by the wheel's

circumference. Tiring of the process, he used wooden cog wheels attached to the hub of a wagon wheel, which counted the revolutions for him.

An entry in his journal reads, "About noon today Brother Appleton Harmon completed the machinery on the wagon called a 'roadometer' by adding a wheel to revolve once in ten miles, showing each mile and also each quarter mile we travel, and then casing the whole over so as to secure it from the weather."[115]

Clayton—clerk, scribe, entrepreneur, business man, inventor and poet—died on December 4, 1879. His body was interred at the Salt Lake City Cemetery. His place at Pioneer Memorial Park is only fitting, however, as Clayton left a legacy for Latter-day Saints then, now and in the future.

OF FAITH AND A FORT

In 1800s Utah, travelers on the open desert would often come under attack by Indians. Weather sometimes also was harsh, and just the fatigue and hardship of the travel experience was enough to cause anxiety for many. One respite for those who came by central Utah was a fort named Cove that today is open for tours hosted by missionaries of The Church of Jesus Christ of Latter-day Saints.

"Built in 1867, Cove Fort was constructed as a safe stop for travelers, where they could find shelter, fresh water, and feed for livestock," reads an entry on the LDS website under "Historic Sites." "Go back in time to the days when travel was by horseback and covered wagon and discover what sort of accommodations a traveler could have expected."[116]

The fort today, located about twenty-four miles north of Beaver in Millard County at a place called Cove Creek, is modeled as it would have appeared when it was in use more than one hundred years ago, and its friendly volunteer staff will greet visitors with smiles and answers to their questions. They take pride in the fort, a marvel amid the backdrop of modern day and the only fort built by the church that still stands.

It started when Brigham Young called on Ira Hinckley to direct the construction of the one-hundred-square-foot lava and limestone rock facility. For about seven months, between April and November 1867, workers quarried the rock from nearby and secured cedar and pine wood for the roof and doors at the east and west ends. The fort stands eighteen and a half feet tall and is about four feet thick at the footings and two and a half feet

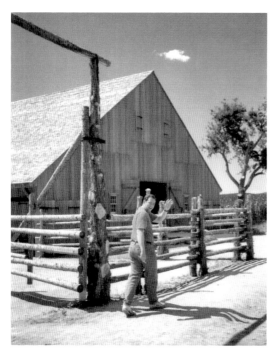

The author waves to the camera as he tours one of the barns during a '90s visit to Cove Fort. *Photo by Heidi Weeks.*

thick at the top. The fort has twelve rooms, each furnished to look as it would have during its heyday.

> *For more than twenty years Cove Fort served an important function, but as times changed so did the need for the fort. By 1890 the Church leased out the fort and after the turn of the century, sold it to the Otto Kesler family. Nearly one hundred years later, in 1988 the Hinckley family purchased the fort from the Keslers and made a gift of it to the Church as a historic site. Shortly afterward, efforts to restore the fort to its original condition were begun, and on May 21, 1994, Gordon B. Hinckley, later president of the Church of Jesus Christ of Latter-day Saints, dedicated the Historic Cove Fort Complex.*
>
> *"It is our hope that Cove Fort will serve as a modern way station—not as a shelter from physical fatigue or protection from the elements—" said Stephen D. Nadauld, speaking at the 1994 dedication, "rather, we hope it will serve as a spiritual way station where we can be reminded of the faith of our forefathers, where we can refresh our sense of sacrifice and obedience and our dedication to duty, where we can be reminded of the values of work, provident living, self-sufficiency, and family unity."*[117]

TABERNACLES AND OTHER HISTORIC BUILDINGS

Logan Tabernacle and Organ

In a day without giant Caterpillars and cranes, it sometimes took workmen years to construct buildings. In the case of the Logan Tabernacle, it took twenty-seven years. It has become an iconic symbol of faith of the Mormons who helped settle northern Utah.

Constructed with all local material, the tabernacle was dedicated in 1891 by church president Wilford Woodruff. Construction started in 1864. The Tabernacle, a classy and reverent building in the heart of Logan, welcomes visitors of all faiths to learn a little something about the building and its magnificent pipe organ and be enthralled by the pioneer craftsmanship on display.

During a tour of the building in early August 2015, my son and I learned from a friendly tour guide that one of the reasons it took so long to complete was because church members often stopped construction to work on the Logan Temple. When the edifice was completed, it wasn't long before some changes were implemented, including replacing stairways, the installation of stained glass windows and replacing pews.

The multi-pipe organ that serves as the building's elaborate centerpiece is still played today during tours and local religious and community events. The building also has a modern-day baptism font used by stakes in the area, and in the basement is a Family History and Genealogy Center, open to

members and nonmembers alike as a means to search their ancestral past. The computers and copy machines would normally look out of place in such an old building, but the basement has been modernized to complement the work that takes place here.

Box Elder Tabernacle

On May 9, 1865, two men with shovels in hand laid the cornerstone of what has since been called the Box Elder or Brigham City Tabernacle. Over the ensuing years, the building, donned in easy brown and egg-shell white, served as a beacon to the growing community because President Young placed it on Sagebrush Hill, the highest rise in the area. In 1971, 106 years later, the building was placed on the National Register of Historic Places. It today still stands as a monument of faith and pioneer spirit. It also is the place where in 1890 Wilford Woodruff announced the proclamation denouncing polygamy from the church, setting the faith's course into modernity and more mainstream Christian acceptance.

As with any enterprising endeavor, the project didn't come easy, though it became *easier* in 1867 after the railroad helped workmen haul needed materials to the site. They garnered material—sandstone and lumber—from the nearby mountains while the women sold homemade items to raise money to purchase glass and other beautifying emblems that would decorate the tabernacle. Sadly, Brigham Young, who died in 1877, never saw the completed building. It was the church's third president, Wilford Woodruff, who dedicated the tabernacle on October 28, 1890—though the first meeting took place in the partially completed structure on May 27, 1879.

Like mortal men, buildings also decay and at those times need a little extra attention. For the buildings, this often comes in the form of remodel or renovation. Sometimes, because of circumstances by time or nature, a complete overhaul is needed. This tabernacle received at least a couple.

According to one story, on February 9, 1896, as Latter-day Saints gathered inside the building for Sunday worship, a fire started in the furnace room. Thankfully, no one was hurt in the blaze. Once remodeled more than a year later, it donned a new gothic-looking tower and sixteen pinnacles. It was rededicated March 21, 1897 by Apostle George Q. Cannon, first counselor to President Wildford Woodruff. The building received further upgrades in the 1980s, including reinforcing the structure and installing a new electrical system. It was rededicated on April 12, 1987, by Elder Boyd K. Packer.

Wasatch Stake Tabernacle

Latter-day Saints take great pride in their buildings. They are classy, clean and orderly. They are not overly decorated with murals and stained glass windows; most do not contain extravagant details. They are simple facilities of reverence and worship; despite their modest decorations, they are elaborate and architecturally magnificent structures. One of them is the Wasatch Stake Tabernacle.

Located in Heber City in Utah's Wasatch County, the tabernacle was completed in 1889, taking two years to construct at a cost of some $30,000, and served as the meeting house for area Latter-day Saints for nearly one hundred years. Built for a seating capacity of 1,500, the building was listed on the National Register of Historic Places on December 2, 1970. In 1980, it was sold to Heber City and since has functioned as a venue for community events.

St. George Tabernacle

Reaching 140 feet high, the bell tower on the St. George Tabernacle and its clock, peering from the steeple like an all-seeing eye, are just a couple things that make this historic building memorable. Opening in 1876, the tabernacle was built for two purposes: to host church services and court hearings. Today, it plays host to concerts and other community gatherings, as well as an array of visitors who stop by regularly to learn more about the building and the community it serves.

St. George, southern Utah's most famous city, was settled by the Mormons in the latter 1800s and had a warm climate just right for growing cotton. But as the Saints settled, they found the area was a boon for other purposes, too, and it became a place that remains a favorite for those who like a warmer climate. Naturally, they built according to their accommodations, and the tabernacle was one.

Paid for by tithes from church members, construction began on June 1, 1863, and was dedicated three years later, on May 14, 1876, by Brigham Young Jr., son of the prophet. Red sandstone bricks were used in the construction with the intent to match the red sands and cliffs of the St. George area. The color also contrasted with the stark white St. George Temple, which had another year before it was completed. In all, it held some 1,200 people.

The ceilings of this building reach 29 feet high and is supported by 20 columns. It has a clock tower, where in the days of its creation local residents would turn to tell time. An organ was added in 1878. If you visit the tabernacle today, you might hear it called by another name: Jewel of the Desert. After visiting, you'll know why. It is indeed a special monument, a jewel not only to the Desert West, but to the community-minded Mormon faith.

The Deuel Log Home

Not all of the pioneers who traveled to the Salt Lake Valley in 1847 arrived under a summer's blue sky. People were still arriving later that year, and as the sky turned metallic and the snow began to fly, the newly arrived Saints needed a place to shelter themselves from the elements of the ensuing winter months. Forts and log homes were constructed, and one of the first was the Deuel Log Home that now sits in downtown Salt Lake City, between the Church History Museum and the Family History Library.

"The Deuel Log Home was constructed in 1847 in the north extension of a pioneer fort, part of a massive building project to provide shelter for the approximately 1,600 people who spent the winter of 1847–48 in the Salt Lake Valley," reads an entry on the Church Museum website. "Immediately after Brigham Young's company arrived in the valley in July 1847, there were several important and urgent tasks at hand. One of these tasks was to provide protection for the settlers from possible attack by American Indians. A second urgent need was to provide shelter for themselves and those on the trail who would arrive within a few weeks. Both requirements were met by constructing the fort, with housing built within its walls."[118]

The small house is an interesting addition to downtown Salt Lake City, where modern buildings dot the landscape. Located across the street is Temple Block, however, and being placed outside the church museum makes it a fitting location for this old log house despite the modernity that surrounds it.

Torrey Log Church/Schoolhouse

It resembles a scene out of *The Little House on the Prairie*, but this community building is all Utah. Built in 1898, the Torrey Log Church/

Schoolhouse—some thirty-seven by twenty-one feet—is a single-story facility set amid beautiful country in central Utah's Wayne County. It has a bell tower and red sandstone steps that add to the iconic flair of this pioneer building.

For nearly twenty years, students of all dispositions came here to learn something of faith as well as the secular world. It served as a school until 1917, when a new multi-use building was constructed; and even though a new meetinghouse was built in 1928, it continued to be used for various religious and social gatherings until the 1970s.

According to one site, "It is the only known example of a log meetinghouse still standing in the state. The building is made of sawn logs joined at the corners with carefully executed half-dovetailed notching. The building was relocated approximately 100 yards to the west to make room for the expansion of the neighboring 1928 sandstone meetinghouse. The Daughters of the Utah Pioneers have restored the building and are using it as a place to hold local meetings, continuing its traditional use for religious and social functions."[119]

Pine Valley Chapel

When LDS missionaries went abroad in the early days of church history, they not only gathered gospel converts but talented artisans, stonemasons and welders as well. People possessing skills and talents of all varieties came into the church. And within the body of Mormonism, they found not only a place of worship but also a place to use their God-given talents to further the work of the Lord—people like Ebenezer Bryce, a Scottish convert and shipbuilder. A couple things for which ole Bryce is known: Bryce Canyon National Park in southern Utah was named after him, and he designed the historic landmark known as the Pine Valley Chapel near St. George. To many, its attic resembles the bottom of a ship.

"After workers had hoisted the building sides into place, in unison, the corners were wrapped with strips of green rawhide that tightened as they dried and formed solid corners," according to information from the St. George Temple Visitors Center. "The outside of the building was covered with shiplap made of half-inch boards about six inches wide, fitted over each other at the edge. The building would be two and one-half stories tall with the rafters for a roof put on and braced with huge timbers 10 to 12 inches in diameter. A later generation would climb steep, narrow stairs and look with awe through the glass partition to marvel at the attic built to resemble the bottom of a ship."[120]

A shipbuilder by trade, it came as no surprise that ol' Bryce included a ship's feature in the two-story building. A ship's feature is perhaps fitting in that the building, used at the time as both school and chapel, helped set the sails of young people as they came to learn about life and the gospel. The ground floor was used as the school. "The second and main floor was a multi-purpose room. It would serve as a chapel for Sunday worship, at other times a stage outlined by a curved arch for dramas during the week and when the slat benches were moved back they could enjoy dances, parties and branch dinners. They were proud of a curved ceiling that was suspended from a frame in the attic. It perfectly matched the arch over the stage. The members were delighted."[121]

The scenic little area of Pine Valley and its celebrity building has a big history. Visit the site to learn more about this happy little place that continues to serve as a bright spot in Utah history. The chapel and adjacent tithing office were listed together on the U.S. National Register of Historic Places in 1970.

JACOB HAMBLIN HOME

Jacob Hamblin, a member of the Quorum of Twelve Apostles during a volatile period in Mormon Church history, was called the "Buckskin Apostle" because of his work among the Indians. As one story goes:

> *November 1863. Jacob Hamblin had just left his home in Santa Clara to get supplies in nearby Cedar City, Utah. Two Indians rode up to the Hamblin home and angrily demanded: "Where is Jacob?"*
>
> *When they learned he had gone to Cedar City, they dashed off in that direction with their horses. Overtaking Jacob, they called for him to stop.*
>
> *"We have come to kill you!" they called angrily.*
>
> *For a few moments there was silence. Then Jacob climbed down from the wagon seat, looked at the Indians, and pulled his shirt open—as if to say, "Shoot, I am unarmed."*
>
> *The Indians stared a moment in silence. Then one muttered: "Can't Jacob, you've got my heart." They rode away.*
>
> *Jacob Hamblin. At a time when few white people were trusted, the Indians looked upon Jacob as a true friend. Today he is considered the most influential and successful peacemaker and missionary among the Indian people in the territorial period.*[122]

Hamblin was born on April 2, 1819, in Salem, Ohio, and joined the LDS Church a month before his twenty-third birthday in 1842. His first marriage ended when his wife, Lucinda, refused to go with him to Salt Lake City during the great migration. He, a devout follower of his Mormon faith, believed it was his duty to join the body of the Saints in the Rocky Mountains, his marriage notwithstanding. He packed his belongings, said a prayer and parted ways with his wife, bringing his four children with him. That was February 1849. But that September, he met and married widow Rachel Judd in Council Bluffs, Iowa. Under the church's blessing, he married two other women, fathering children from each union. Once in Utah, he settled in Tooele in 1850. Soon after arriving, he and other brethren had a run-in with Indians. He drew his pistol to protect himself, as did his brethren, but each of their guns had misfired. One gun not working properly could be an accident, but several?

"As I could not discharge my gun, I defended myself as well as I could with stones," he wrote. "I afterwards learned...that not one [of our company] was able to discharge his gun when within range of an Indian...It appeared evident to me that a special providence had been over us...to prevent us from shedding the blood of the Indians. The Holy Spirit forcibly impressed me that it was not my calling to shed the blood of the scattered remnant of Israel, but to be a messenger of peace to them. It was also made manifest to me that if I would not thirst for their blood, I should never fall by their hands." God had intervened and, Hamblin believed, called him to be a "messenger of peace" to the Natives.[123]

Four years after his arrival, President Brigham Young called Hamblin to serve as a missionary to the Paiute Indians in southern Utah. Hamblin, believing when a prophet called it was God's will, packed his belongings and led his family south, settling in a place called Santa Clara near St. George. After their first home was destroyed by flooding, Hamblin built a second home on a hill in 1863. It is this same home that, restored, stands today as a historical marker of the faith in southern Utah.

"The Hamblin home, which is fronted by an immense green lawn, fallow wine orchards and a towering cottonwood, features a small formal mid-house entryway, flanked on either side by two bedrooms."

> *Each bedroom features a small, steep, narrow stairwell which leads upstairs to a broad, impressive common area. Used for school-teaching, community meetings and family activities—Hamblin's community stature meant he was a father figure to many—this house-wide room has a vaulted ceiling, fireplace and a porch.*

> *Eventually, Hamblin's daughters demanded privacy—they had been sharing the common area with the boys—and Hamblin added what tour guides today call the "girls' dormitory," an addition off the back of the house big enough for four beds and dressers.*[124]

Hamblin enjoyed the home only briefly, as he was called in 1869 to serve missions in Kanab, Utah, and parts of Arizona and New Mexico—each with a focus of administering to the Native Americans.

His Santa Clara house today serves as a museum. Church missionaries give tours and instruct visitors on the history of the house and surrounding area. It's a cozy-looking house set amid a serene setting with a garden and flowers on its property, making it look every bit as lived in as it did when Hamblin and his clan lived here in the mid-1800s.

Brigham Young Winter Home

St. George in southern Utah is a popular destination spot for all types of people, including those who want to escape the colder regions in winter. Snowbirds—those who seek warmer climes when the snow flies—come here to bask in the shirt-sleeves weather when other places in the state, such as Salt Lake City, may be experiencing teen or even single-digit temperatures. St. George has attracted such warm-blooded visitors for a long time. Brigham Young was one of them. The second president of the Mormon Church, in fact, has been called St. George's first snowbird.

Induced by age, the prophet began suffering from arthritis in the late 1860s. While visiting the warmer climate of southern Utah, he found he didn't ache as much as he did in Salt Lake City. It prompted him to build a home in St. George that he could visit during the winter months. Begun in 1869, the two-story adobe rock and plaster home was completed two years later, in 1871, with an addition to the front completed in 1873. Wrapped with a large porch, the house also had a detached office and telegraph station.

The Brigham Young Winter Home, located at 200 North and 100 West, sits in a neighborhood of other pioneer homes. During a walking tour, you can see more than two dozen of these historic buildings in a climate that is warm, a community that is friendly and an area that is beautiful in its own right.

ALL IS WELL WITH CHURCH WELFARE

A common tenet among members of The Church of Jesus Christ of Latter-day Saints is that God helps those who help themselves. The Saints also believe that it is their obligation, even a part of their covenant-making, to lend a helping hand to those in need. This does not mean monetary donations, necessarily, though the church does have an orderly system to receive such donations. It also operates energetic and innovative welfare centers in Utah and other parts of the country and globe. Church-owned farms grow a variety of produce and livestock, while certain facilities prepare, package and ship the homegrown items to bishop storehouses in Utah and beyond.

Bishops storehouses are stockpiled with foodstuff and other commodities, and members of the church who are out of work or challenged financially may, at their branch president's or bishop's discretion, visit the store to "shop" for food free of charge. These types of services are not meant to offer long-term assistance, but help people get back on their feet. Monetary donations from church members, often given through monthly fast offerings, go to help fund and provide the necessary items. The church also runs family counseling services and employment centers that help those distressed or out of work find jobs related to their skills and experience. All of these entities have blessed countless individuals and families, not only in Utah but in many places across the country and many parts of the world. They are a hallmark of Christian service and very much a monument of faith.

"Our main purpose," wrote the First Presidency in a 1936 letter distributed among the Latter-day Saints about Church Welfare Service, "was to set up, in so far as it might be possible, a system under which the curse of idleness would be done away with, the evils of a dole abolished, and independence, industry, thrift and self-respect be once more established amongst our people. The aim of the Church is to help the people help themselves. Work is to be re-enthroned as the ruling principle of the lives of our Church membership."

One of the more notable gems in the western states is Deseret Industries, often referred to simply as the DI, which helps struggling members and nonmembers alike by providing jobs and the opportunity, among other things, to develop employable skills.

Deseret Industries

After more than 20 years as a machinist, Morgan Layton was out of work and couldn't find a job in Southern California.

His parents lived in Idaho and, as they were getting on in years, he moved to Jerome to be closer to them. He also hoped the move would increase his chances of finding work. But a year and a half later he still was out of a job.

Then he was referred to Deseret Industries in Twin Falls.

"It's the only place that offered me a job," he said.

Layton, who on Thursday was busy stocking shelves, now works at the store full time while pursuing his career goals in manufacturing by working toward a certificate at the College of Southern Idaho. What's more, the store is paying his way through school.

Layton is not unlike hundreds of others who, finding themselves out of work, have found help through the Deseret Industries program, which allows people to earn an income, enhance skills and work at becoming self-reliant.

Deseret Industries, owned by The Church of Jesus Christ of Latter-day Saints, is supported through donations from community members, said Twin Falls store manager Wayne Tonge. People know it as a thrift store, but Tonge said it's much more than that.

The store employs 11 staff members and 66 associates, he said. Associates are at the store temporarily, just long enough for them to get on their feet and find other work. So far this year, the store has helped place 34 associates into other jobs.

"It's about helping people progress," he said. "We want people to be self-reliant."

Though the above story, taken from a longer article I wrote for the Twin Falls *Times-News* in 2011, is about an Idaho thrift store, the mission is the same for all Deseret Industries. The chain is owned and operated by the LDS Church. Those who shop its aisles know the bargains they can buy; but the real dividend of the chain is how it helps those who are out of work, oftentimes those who are physically, emotionally or socially challenged and find it difficult to find jobs at other businesses. Not only does it provide an income for those hired, but it gives them confidence in their abilities and in the waiting process as they look for more steady opportunities. Their work at the DI helps them to become self-reliant while at the same time allowing them to learn skills that make them more employable in the job market. The chain, for the most part, is more of a rehabilitative opportunity for people rather than offering careers, though there are some that find long-term employment.

For customers, the stores provide apparel and merchandise of all sorts at reasonable prices. Many of the goods are secondhand or used items but have been cleaned, repaired and are usable. Much like the Salvation Army thrift stores, people donate items to the DI. They can either drop off items at the stores or, depending on their proximity to a store location, can call for pickup.

Established in 1938 under the church administration of Heber J. Grant, the First Presidency and Presiding Bishopric sent letters to Salt Lake Valley congregations, asking members to contribute "clothing, papers, magazines, articles of furniture, electrical fixtures, metal and glassware" to the cause. According to an entry on the Encyclopedia of Mormonism by Michael C. Cannon, from whence the following information is taken, the letter explained the church could make "periodic collections of these materials from homes…and employ men and women to sort, process, and repair the articles collected for sale and distribution among those who desire to obtain usable articles…at a minimum cost."[125]

Church leaders caught the vision and then shared it with members, who for almost eighty years have shared in that vision by making the thrift store chain a successful venture and another monument of faith to the Latter-day Saints. Deseret Industries can be found in Utah, Arizona, California, Idaho, Nevada, Oregon and Washington.

NEWS OF THE DAY, YESTERDAY AND TODAY

Deseret News

When the Latter-day Saints arrived in Utah, having isolated themselves from their persecutors in the Midwest, they still wanted to keep abreast of the happenings of the day, both in their new home of Deseret and other parts of the country. One of their revelations, D&C 88, given to Joseph Smith in December 1832, instructed the Saints in verse 118 to "seek…diligently and teach one another words of wisdom; yea, seek ye out of the best books words of wisdom; seek learning, even by study and also by faith." Further revelations emphasized seeking after knowledge, such as D&C 90:15, which counseled members to "study and learn, and become acquainted with all good books, and with languages, tongues and people." And in D&C 93:53: "Obtain a knowledge of history, and of countries, and of kingdoms, of laws of God and man, and all this for the salvation of Zion."

Books and newspapers, history and journalism, all played an important role in the early church as they do today. An enlightened people want to remain informed, which in today's digital world is much easier to do. So, what did the Latter-day Saints do when they first came to Utah? Opened their own newspaper and bookstore, of course. Staying with tradition, they named these ventures after what they called their New Zion, Deseret.

"The *Deseret News* is the first news organization and the longest continuously operating business in the state of Utah," boasts a description

on the newspaper's website. "Owned by the Church of Jesus Christ of Latter-day Saints, The *Deseret News* offers news, information, commentary, and analysis from an award-winning and experienced team of reporters, editors, columnists, and bloggers. Its mission is to be a leading news brand for faith and family oriented audiences in Utah and around the world."

It started out much smaller than it is today, and news gathering is in many ways different than it used to be, but what has remained is its bent toward conservatism and faith in its reporting.

It all started on March 31, 1847, at Winter Quarters, Nebraska, when the Quorum of Twelve Apostles charged William W. Phelps to head east to secure a printing press that the Saints could take with them to the Rocky Mountains. Phelps left to fulfill his assignment the following May, securing a large and heavy press in Boston. But because it was so heavy, proper transport to the Salt Lake Valley was not available for another two years and it didn't arrive in the Great Basin until August 7, 1849. The following year, on June 15, 1850, the first edition of the *Deseret News*, with "Truth and Liberty" as its motto, was published as an eight-page broadsheet. Among the stories of that first edition was news from the capitol and, lacking the immediacy of the World Wide Web, a six-month-old story on the San Francisco Christmas Eve fire of 1849. Eventually, Apostle George Q. Cannon oversaw the production of the newspaper and book publisher.

As with today's journalists, the reporters of the early editions had to be enterprising and stick their noses into issues to find out what should be reported to the reading public. Breaking news happened as it does today, both at home and abroad, and on top of that there often was something to write about from the church. A challenge then, as it is with modern newsrooms, was trying to cover as much news as possible with minimal staff. They did not have to worry

An early copy of the *Deseret News*, a church-owned newspaper headquartered in Salt Lake City. The paper, which serves as a different type of monument to the LDS people, is still in print today. *Photo by Andy Weeks.*

about the Internet, social media or blogging, but the reporters of the day still had to know their beats and promote themselves and their work. They were quasi-public figures, and it was a blessing and a burden to be in their presence.

Another challenge was the lack of paper to print the day's news. The press shut down for three months in the fall of 1850, in fact, even after going to a biweekly publication, due to the lack of paper. No one ever said Mormons weren't resourceful, however, and with approval from Brigham Young, a Mormon convert and papermaker from England named Thomas Howard used a sugar-producing machine and old paper and cloth donated by church members to create a unique brand of newsprint. The gray-looking paper was thicker than normal newsprint, but it seems to have done the job.

The church today has many media outlets in Utah, including radio, television, cable and Internet. It also operates its own book publisher and retail bookstore chain, called Deseret Book, producing and selling unofficial LDS-themed books, art, music and other family-oriented products. A number of these retail stores dot Utah and other western states, providing church members with an arsenal of inspirational and faith-promoting material.

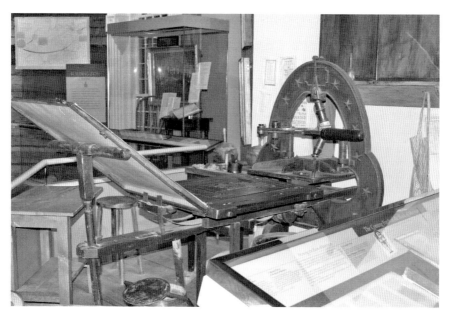

A view of the printing press that printed the first edition of the Book of Mormon in 1830. The press, originally owned by Grandin Printing, is today on display at the LDS Church History Museum in Salt Lake City. *Photo by Andy Weeks.*

Monuments

Outside of the Deseret realm but closely linked to it are Church Distribution Centers that sell official church-sanctioned items such as temple clothing and garments, scriptures, art, missionary literature, music, church videos and movies, lesson manuals, jewelry and other items.

The *Deseret News* and its bookstores are a different kind of monument, a living legacy of faith from which Latter-day Saints and others continue to stay well-informed.

IN THE LAND OF TRAGEDY

Mountain Meadows Monuments

Long before horror befell New York City and the world in 2001, September 11 was marked by an episode of terrorism that occurred in a secluded valley in southern Utah called Mountain Meadows. Today in this otherwise peaceful valley where the wind brushes the tall prairie grass stands a monument listing the names of the victims of a bloody and senseless massacre. But the granite marker is only one memorial to the one-hundred-plus men, women and children who died here. Their phantom cries, carried on the wind, are another memorial. As retold in my book *Haunted Utah*, the drama begins nearly 160 years ago.

September 1857: The Mormons weren't the only people who sought a better lifestyle by packing up their belongings and heading West. In the mid-1800s, thousands of emigrants, after loading their handcarts and wagons, set off on the Oregon Trail. Some headed to the Pacific Northwest, while others took alternate routes though Utah and on to Southern California. One company on their way to the Golden State was the Alexander Fancher and John Twitty Baker party, composed mostly of families from Arkansas. They were a peaceful lot, seeking to do only what others had done before them. Their plans changed drastically when they stopped to rest in a lush meadow in southern Utah.

A fanatical band of Mormons allegedly feared that the emigrants had ulterior motives for coming to Utah, perhaps to spy on the Mormons for

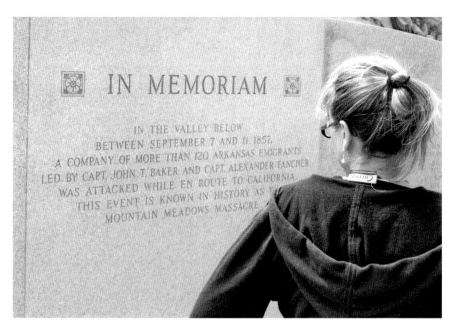

The author's wife, Heidi, reads a memorial sign at Mountain Meadows, the site of a grisly massacre in 1800s Utah. The site today is a reverent and solemn spot with many markers remembering those who lost their lives here. *Photo by Andy Weeks.*

the government, who vowed they'd not again be forced out of their homes as they had been in Missouri and Ohio. Brigham Young didn't help matters with his war rhetoric. At one time during this period of contentious time between the church and government, he was quoted as saying, "I tell you, the Lord Almighty and the Elders of Israel being our helpers, they shall not come to this territory. I will fight them and I will fight all hell."

In southern Utah, John D. Lee and others conspired in secret to commit mass murder—which goes against everything the church and good people everywhere believe: that all life is sacred. But there's no reasoning with warped minds. The group would initiate the help of the Paiute Indians, and together they'd lay waste to the emigrants. It didn't seem to bother the killers that the group consisted mostly of women and children. But even the emigrant men were blameless. The planned attack was set to occur on September 7. The morning dawned quiet for the emigrants, who were sitting around eating a "breakfast of rabbit and quail" when "a shot rang out and one of the children toppled over," according to an account by survivor Sarah Baker. More shots followed in quick succession, and the shrieks of

A History of Mormon Landmarks in Utah

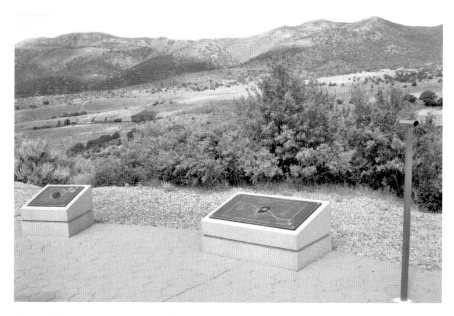

Some of the many markers located at Mountain Meadows. *Photo by Andy Weeks.*

Indians emanated from a nearby ravine; a few minutes later, seven men lay dead at the camp.

For the next five days, the Baker-Fancher emigrant company huddled in the circle of their forty wagons trying to protect themselves from the onslaught of the Indians—and Mormons who had dressed like Indians—that surrounded them. Things weren't looking good for the emigrants. Food and water were running low; some of the emigrants were sick. And then on September 11 a white flag appeared, and members of the Utah Territorial Militia approached. It appeared to the emigrants as if deliverance was near after all. But the militia members, including Lee, had hatched another plan to fulfill their evil deed of murder. They told the emigrants that to pacify the Indians they must give up their arms and submit to the militia. No harm would come to them, they were told. The militia members would lead them safely out of harm's way, first to Pinto and then to Cedar City.

Word quickly spread through camp, and the emigrants, not knowing what else to do under the circumstances, put their trust in this group of Mormons, who at the time appeared as their saviors. They surrendered their arms. The emigrants then were told to separate into groups, the men into one group, the women and children in another.

Monuments

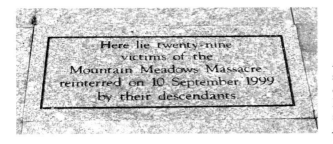

A marker attesting the sad fate of some of the emigrants who died at Mountain Meadows in southern Utah. *Photo by Andy Weeks.*

In hindsight, the whole scenario has all the markings of a death trap. When the militia members had led the emigrants several yards from camp, the shout was given: "Halt!"

And the slaughter commenced.

The plan was to kill everyone older than eight years, but during the frenzied slaughter several young children also were murdered. One report says that an Indian stabbed an infant while its mother held the baby in her arms. The horrific episode, one of the darkest in Mormon and Utah history, lasted only five minutes but when it was over, more than 120 men, women and children lay dead and bloodied on the prairie, their bodies shot, hacked, slashed or bludgeoned to death. It didn't matter that some had begged and pleaded for their lives; their answer was the slash of a knife or the discharge of a bullet.

The seventeen children who were spared, those young enough to perhaps not remember the perpetrators of the ghastly crime, were gathered up and distributed to some of the area families. As for Lee, who became somewhat of a scapegoat for the massacre, he bragged for the first couple weeks about his part in the killings but then for the next twenty years denied having had anything to do with it. Such was the story of many of the men who participated in the slaughter. In 1872, then going by the name of Major Doyle, Lee opened a ferryboat crossing near present-day Lake Powell. He was executed by gunshot in 1876 for his part in the crime.

"The story of the most violent incident in the history of the America's overland trails remains among the West's most controversial historical subjects," writes historian Will Bagley in his hallmark book *Blood of the Prophets*, "yet even students of the American West have nearly forgotten the event. Most Americans, including many Utahns, have never heard of it."

Who's to Blame?

Many other books, by authors savvier than me, have tried to answer the questions of why the Mountain Meadows Massacre occurred. What led a band of Mormons, who subscribe to the biblical and humane belief that murder is a grave sin, to commit such an atrocious and bloody act? Answer: there was no reason, just as there never is, for mass murder. One cannot fathom the thoughts that run through a twisted mind like John D. Lee, John Higbee, Nephi Johnson and the other perpetrators of Utah's darkest deed.

Because of Lee and his brethren's evil act, the church was deemed the culprit by many, some even going so far as to say that Brigham Young, while never giving orders to commit such an atrocity, fueled animosity among the Saints by his war rhetoric. The Mormons had been persecuted and driven by mobs from state to state; they had witnessed the slaughter of their own people at Haun's Mill in Caldwell County, Missouri; their own prophet, Joseph Smith, was gunned down in cold blood while imprisoned on false charges in Carthage, Illinois. When the Saints settled in Utah Territory, they vowed they would not be persecuted and driven from their homes again.

The fact of the matter is, Young did not approve of the evil deed nor did he condone it after he heard about it. Lee and his comrades acted on their own, and church presidents, such as Joseph Fielding Smith, denounced the crime as a "bloody and diabolical deed" and as the most "horrible and shocking crime ever perpetrated" in Utah.

On the 150th anniversary of the tragedy, September 11, 2007, the LDS Church, in an effort to honor the victims and acknowledge their posterity, held a ceremony dedicated to the victims and their families. Elder Henry B. Eyring, reading a prepared church statement at the event some thirty-five miles northwest of St. George, said:

> *We express profound regret for the massacre carried out in this valley 150 years ago today and for the undue and untold suffering experienced by the victims then and by their relatives to the present time.*
>
> *A separate expression of regret is owed the Paiute people who have unjustly borne for too long the principal blame for what occurred during the massacre. Although the extent of their involvement is disputed, it is believed they would not have participated without the direction and stimulus provided by local church leaders and members.*[126]

According to a *Deseret News* article by Carrie A. Moore published the next day:

Monuments

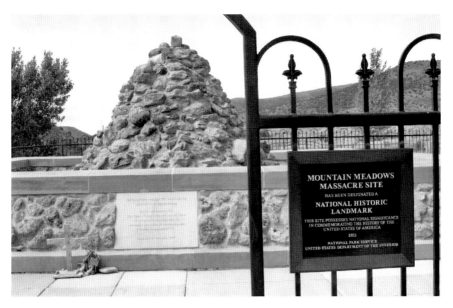

A church-built memorial at Mountain Meadows in southern Utah. *Photo by Andy Weeks.*

Elder Eyring said that research by church historians...found that church President Brigham Young's message "conveying the will and intent...not to interfere with the immigrants arrived too late." The research also found that the "responsibility for the massacre lies with the local leaders of the The Church of Jesus Christ of Latter-day Saints in the regions near Mountain Meadows who also held civic and military positions and with members of the church acting under their direction."

Several hundred descendants of the victims traveled across the country to attend Tuesday's ceremony. Many of them had sought an apology from the church since the dedication eight years ago of a monument marking the burial site of some victims.

Some have also petitioned the church to transfer to the federal government stewardship of the monument and surrounding lands the church has purchased to preserve the site that church President Gordon B. Hinckley has described as sacred ground.

In addressing that proposal, Elder Eying said, "The church has worked with descendant groups...to maintain the monument and surrounding property and continues to improve and preserve these premises to make them attractive and accessible to all who visit. We are committed to do so in the future."[127]

The locale is a pretty spot in rural southern Utah, where the wind still rustles the prairie grass. It's easy to feel reverent here, if not a bit haunted, as you consider the lives that were lost in this fertile valley. Several monuments decorate the area, including a marker that lists the victims' names. The largest of the monuments is a stone pillar that honors those who came here to rest for a few days and instead found eternal sleep in its meadow. If you plan to come here, make sure to bring your camera and maybe a tissue or two.

HISTORY ON DISPLAY

Church History Museum

As a new convert to the church, I remember visiting the Church History Museum in downtown Salt Lake City with my mother, who took me to see the historic emblems of the pioneers before my mission. The things that stood out to me most were the death masks of the Prophet Joseph Smith and his brother, Hyrum, who were shot and killed by a mob's bullets in 1844. I could easily make out the facial wound on Hyrum's face, where a volley had struck him, ending his life. In a display case sat the wooden cane that Willard Richards, friend and church member imprisoned with the prophet, used to try to fend off the attackers at the prison door. In the case also was the pocket watch that stopped a slug and, sitting in the coat pocket of Apostle John Taylor who also was imprisoned with his brethren, saved the future church president's life. I'm glad to hear that the newly remodeled church museum, which opened in the fall of 2015, will retain the death masks.

A couple weeks before its temporary closure in 2014, the *Deseret News* published an article about the renovation and what visitors could expect when it reopened. "For a quarter century, the Church History Museum across the street from historic Temple Square has told the story of the LDS Church though an exhibit called 'A Covenant Restored,'" reads the September 14, 2014 article by Tad Walch.

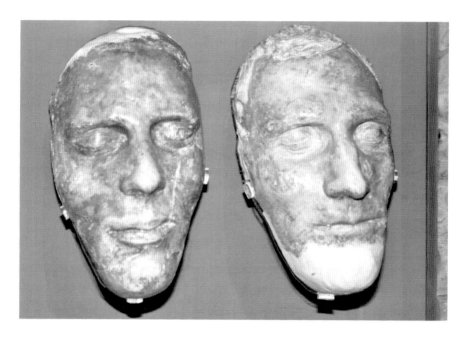

Top: Death masks of the prophet Joseph and his brother Hyrum Smith on display at the Church History Museum before it was renovated in 2014–15. The death masks remain on display in the remodel. *Photo by Andy Weeks.*

Bottom: The pistols used by Joseph Smith and others to defend himself and his brethren while imprisoned on false charges in Carthage, Illinois. A mob stormed the jail, their bullets eventually killing Joseph and Hyrum and wounding Willard Richards. *Photo by Andy Weeks.*

In 12 days, that exhibit will be history, after drawing about 7 million visitors. Not only will the exhibit close, but the museum will shut down for a year-long renovation on Oct. 6, one day after the conclusion of the church's semi-annual general conference, then re-open with an important new film, a major new exhibit and a new floor plan on the ground level.

The new exhibit, "The Heavens Are Opened," will focus on the years 1820–46 and continue the church's efforts to provide more, and more transparent, information about the faith's origins.

I was excited to read this. As much as I love the church, I always believed it should be more transparent with regard to its history. I applaud the church that in recent years it has published more forthright and explanatory material concerning the life and actions of Joseph Smith, such as the reasoning behind the prophet's stance on plural marriage and why there are several accounts of the First Vision. You can find some of these "Gospel Topics Essays" on the church website—and now be better informed with the remodeled Church History Museum. The article continues:

"We want members of the church and people outside of the church who are looking for information to get a very consistent message," [the museum's senior curator Kurt] *Graham said. "We don't want them to hear one thing in the museum and then something else on the church's internet site*

The watch that saved John Taylor's life while imprisoned at Carthage with Joseph Smith, his brother Hyrum and Willard Richards. *Photo by Andy Weeks.*

A History of Mormon Landmarks in Utah

Photos of some of the Prophet Joseph Smith's work. Besides translating the Book of Mormon from ancient-made plates, he also interpreted revelations and clarified teachings of the Holy Bible. *Photo by Andy Weeks.*

and something else at a historic site and something else in the Smith papers. It's all one message. We want to coordinate that so that the real, latest scholarship we're aware of is available in all of these venues, in all of these channels, for the public."

The new first-floor exhibit will have eight sections that significantly upgrade the use of media and technology in the museum, including the First Vision Theater where visitors will see a new movie, now in production, depicting Joseph Smith's descriptions of his 1820 vision of God the Father and Jesus Christ.

"I think the church has entered an era of increased transparency when it comes to how it deals with its past," Graham said. "We have multiple

accounts of the First Vision that both Joseph and others around him recorded at different times. We will be sharing all of those versions."

Renovation of the museum began in late 2014, with 1,200 items relocated that will stay in the building and another 6,300 that went into long-term storage. Since the publication of this book, the museum has again opened its doors to the public. The best way to learn about what it now contains, and the experience it offers to guests, is to visit it yourself. I'm sure you'll have your favorite display, just as I had mine.

RESEARCHING AND PRESERVING THE PAST

Family History Center

The Family History Center, which sits next to the Church History Museum in downtown Salt Lake City, is a massive collection of genealogy where members and nonmembers may go to research their ancestors among some 2.4 million microfilmed rolls of ancestry. An accomplished and friendly staff direct the work, while a crew of service missionaries answer patron questions and instruct visitors on search techniques and computer know-how.

The Salt Lake Genealogical Library, forerunner to the present-day Family History Center, was established in 1894 in an effort to research, collect and make available genealogy. The modern facility is the largest library of its kind and welcomes nearly two thousand visitors every day at its downtown facility. What's more, there are nearly five thousand smaller Family History Centers in more than 130 countries.

If you come here with a purpose, perhaps a question or two about your ancestral lines, chances are you'll leave with some answers—if not the first time, maybe the next. Be patient, because researching one's lineage can, for some, seem frustrating at first; but the testimonies of the successful ones say that once you get in the groove it is an addiction difficult to give up.

Give it a try. Uncover the wacky, weird and wonderful in your family tree. The Family History Center is a good place to start. Good luck!

The author's wife, Heidi, receives instruction from a volunteer missionary for genealogy research at the Family History Center in August 2014. *Photo by Andy Weeks.*

Granite Mountain Records Vault

The Library of Congress, founded in 1800, is the world's largest library. It is an impressive building, with an even more impressive collection of some 160 million items on about 838 miles of bookshelves. According to statistics from the library, its collection includes "more than 37 million books and other print materials, 3.5 million recordings, 14 million photographs, 5.5 million maps, 7.1 million pieces of sheet music and 69 million manuscripts."

When it comes to genealogical material, however, nothing beats the Granite Mountain Records Vault of the LDS Church. Its total—yet ever growing—collection of genealogy: 3.5 *billion*. This material takes the form of microfilm, microfiche and digital media. "Currently," reads a news release by the religion, "the Church is in the process of digitizing the microfilm and making those digital records available through the FamilySearch.org website."[128]

The vault, built in 1965 and tucked away in the mountains near Salt Lake City, is not open to the public, but you can take virtual tours of it online.

A History of Mormon Landmarks in Utah

The LDS Church is recognized in the world as a leading authority on genealogic research and services. The reason genealogy is important to the LDS faithful ties directly to their belief in the eternal nature of families and the role temples play in creating these forever units.

Here's a brief recap: in the secular world, a man and woman are married until death do them part. Some believe it is love that binds their marriage eternally. Mormons, on the other hand, believe it is not love that binds families together forever, but a sacred priesthood rite administered only in their temples. When a man and woman marry in the temple, they are married not until death do them part but for eternity. The children they have under this union also are bound to them beyond the grave. Temples are the same places that Mormons do proxy baptism for their deceased ancestors and accomplish for them the same sealing ordinances they were unable to do for themselves during their mortal lives, making it so ancestors and progeny are sealed together in an ever-growing circle of the eternal family.

The granite vault, the world's largest collection of genealogical records, was built in 1965 in an effort "to preserve and protect records important to the Church," the news release reads. Once records arrive at the vault, four key preservation processes are completed. The first thing that happens is microfilm masters are preserved and safeguarded and then filed away. Duplicates are then created and shipped to many parts of the world, allowing people of many faiths to access the genealogy. Next, microfilm is converted to digital images, making them more easily accessible. Lastly, digital media masters are preserved and updated according to new and increasing technology.

It is a marvelous, detailed process but one that is regarded in the Church as one of the most important. According to LDS teachings, when Christ returns to the earth the second time and ushers in one thousand years of peace, one of the great missions of the Latter-day Saints will be the continuation and eventual culmination of temple work. The ultimate goal is to give every person who's lived on the earth—past, present and future—the opportunity to accept or reject the gospel. Many throughout the centuries have died without gospel knowledge. Mormons believe that those who die without knowledge of the gospel in this life will be taught its principles and doctrines in the world of spirits.[129] On earth, temple work by proxy gives them that chance to accept or reject what has been taught to and done for them. This is the great sum and substance of the temples and the precursor of the work that happens outside, genealogy. In this light, what a boon the material protected in the mountain vaults will be in that millennial epoch.

Flowers of many colors bloom on the grounds of the Jordan River Temple in the spring of 2015 in South Jordan, Utah. *Photo by Andy Weeks.*

Lastly, the LDS Church is big on personal and family histories. Members are encouraged to keep journals, scrapbooks and other records of remembrance. The reason: the present will one day become the past, and accurate record-keeping will help individuals and families stay connected in the genealogical scheme of things. It also can be rewarding on personal, more intimate levels. For me, I have always appreciated the nuggets of family history I've gleaned from a grandmother's writing and genealogy. I hope my posterity will one day feel the same about the memories I leave behind in journals, recordings, photo albums and books.

Appendix

ARTICLES OF FAITH OF THE CHURCH OF JESUS CHRIST OF LATTER-DAY SAINTS

1. We believe in God, the Eternal Father, and in His Son, Jesus Christ, and in the Holy Ghost.
2. We believe that men will be punished for their own sins, and not for Adam's transgression.
3. We believe that through the Atonement of Christ, all mankind may be saved, by obedience to the laws and ordinances of the Gospel.
4. We believe that the first principles and ordinances of the Gospel are: first, Faith in the Lord Jesus Christ; second, Repentance; third, Baptism by immersion for the remission of sins; fourth, Laying on of hands for the gift of the Holy Ghost.
5. We believe that a man must be called of God, by prophecy, and by the laying on of hands by those who are in authority, to preach the Gospel and administer in the ordinances thereof.
6. We believe in the same organization that existed in the Primitive Church, namely, apostles, prophets, pastors, teachers, evangelists, and so forth.
7. We believe in the gift of tongues, prophecy, revelation, visions, healing, interpretation of tongues, and so forth.
8. We believe the Bible to be the word of God as far as it is translated correctly; we also believe the Book of Mormon to be the word of God.

9. We believe all that God has revealed, all that He does now reveal, and we believe that He will yet reveal many great and important things pertaining to the Kingdom of God.
10. We believe in the literal gathering of Israel and in the restoration of the Ten Tribes; that Zion (the New Jerusalem) will be built upon the American continent; that Christ will reign personally upon the earth; and, that the earth will be renewed and receive its paradisiacal glory.
11. We claim the privilege of worshiping Almighty God according to the dictates of our own conscience, and allow all men the same privilege, let them worship how, where, or what they may.
12. We believe in being subject to kings, presidents, rulers, and magistrates, in obeying, honoring, and sustaining the law.
13. We believe in being honest, true, chaste, benevolent, virtuous, and in doing good to all men; indeed, we may say that we follow the admonition of Paul—We believe all things, we hope all things, we have endured many things, and hope to be able to endure all things. If there is anything virtuous, lovely, or of good report or praiseworthy, we seek after these things.

–JOSEPH SMITH

NOTES

Introduction

1. William Clayton, "Come, Come Ye Saints," hymn no. 30, *Hymns of The Church*.

Part 1

2. As quoted by Elder M. Russell Ballard in an October 2008 general conference address titled "The Truth of God Shall go Forth," https://www.lds.org/general-conference/2008/10/the-truth-of-god-shall-go-forth?lang=eng.

"Top of the Mountains"

3. Isa. 2:2.

Part 2

4. Smith, *History of the Church*, 6:317.

The Roots of Mormonism

5. Heb. 13:8.
6. Doctrine and Covenants 135:3 (hereafter cited as D&C).
7. Matt. 4:17–19.

8. Eph. 2:20.
9. Amos 3:7.
10. Amos 8:11–12.
11. Acts 3:19–21.
12. James 1:5.
13. Smith, *History of the Church*, 1:15–17.
14. Ibid., 1:18–20.

Old Scripture Revealed Anew

15. Isa. 29:4.
16. Smith, *History of the Church*, 1:33–35.
17. Ibid., 42–43.
18. Ibid., 45–47.
19. Ibid., 52–54.
20. Title page of the Book of Mormon.
21. Ibid.
22. Moroni 10:2–5.
23. Gal. 5:22–23.

Brigham Young and Succession

24. Dan. 2:44.
25. Holland, "Be Not Afraid."
26. "The Wentworth Letter," https://www.lds.org/ensign/2002/07/the-wentworth-letter?lang=eng.
27. Orton and Slaughter, *40 Ways to Look at Brigham Young*, xiii.

Part 3

28. "Faith in Every Footstep," July 1997, https://www.lds.org/new-era/1997/07/faith-in-every-footstep?lang=eng.

"This Is the Place"

29. "Chapter 47: President Brigham Young's Witness of the Prophet Joseph Smith," https://www.lds.org/manual/teachings-brigham-young/chapter-47?lang=eng.
30. Smith, *Teachings of the Prophet Joseph Smith*, 255.

Temple Square and Nearby Monuments

31. Moses 1:33.
32. John 14:16.
33. John 10:16.
34. 3 Nephi 11:10–11.
35. 2 Corin. 13:1.
36. D&C 76:20, 22–24.
37. Matt. 7:7.
38. *Latter-day Saints' Millennial Star*, Vol. 42, 264–65.
39. 1 Corinth. 15:29.
40. Isa. 2:3.
41. Don L. Searle, "The Conference Center: 'This New and Wonderful Hall,'" https://www.lds.org/ensign/2000/10/the-conference-center-this-new-and-wonderful-hall?lang=eng.
42. *Teachings of Presidents of the Church: Joseph Smith*, 448–50.
43. As quoted in *Teachings of Presidents of the Church: Joseph Smith*.
44. Susan Arrington Madsen, "Lorenzo Snow and the Sacred Vision," https://www.lds.org/friend/1993/08/lorenzo-snow-and-the-sacred-vision?lang=eng.

A Historic Look at Temples

45. McConkie, *Mortal Messiah*, 1:98.
46. Ibid., 99.
47. Ibid., 98.
48. Ex. 3:15.
49. Talmage, *House of the Lord*, 17.
50. Moses 1:1.
51. Ex. 24:16–17.
52. Moses 7:2–4.
53. Ether 3:1–28.
54. 1 Nephi 11–14.
55. McConkie, *Millennial Messiah*, 274.
56. Matthew 17:1–8.
57. McConkie, *Mortal Messiah*, 2:54.
58. Ex. 25:8–9.
59. Ex. 26; 27:1–19.
60. Ex. 29:10–11; for a comprehensive look, see chapters 28–33.
61. Ex. 33:7–11.

62. *Journal of Discourses* 19:312; hereafter cited as JD.
63. McConkie, *Mortal Messiah*, 1:102–03.
64. Ibid., 1:103.
65. 1 Chron. 22:8.
66. 1 Chron. 22:10 [9–10].
67. 2 Chron. 3:1; 1 Chron. 21:28.
68. 1 Kings 6:11–14.
69. 2 Chron. 2:4–5 [4–10].
70. 1 Kings 13–18; see also 2 Chron. 2:2.
71. 2 Chron. 2:7–10; 2 Chron. 3.
72. 1 Kings 8:10–11.
73. 1 Kings 8:12–61; 2 Chron. 6.
74. 2 Chron. 7:1 [1–3]; see also Isa. 56:7.
75. 2 Chron. 16 [12–22].
76. Jer. 52:12–23.
77. Monson-Burton, *Celebrating Passover*, 46.
78. Ezra 1:2.
79. Haggai 2:7 [3–9].
80. See Luke 1:11–19 [5–80].
81. See Luke 2:21–24.
82. Luke 2:29–31.
83. Luke 2:37–38.
84. Luke 2:46 [42–52].
85. Matt. 21:12–13.
86. Matt. 21:14–14.
87. Matt. 27:51.
88. McConkie, *Mortal Messiah*, 1:98
89. 1 Nephi 6:2.
90. 2 Nephi 5:16.
91. Ibid.
92. Jacob 1:17.
93. Jacob 1:18–19.
94. Mosiah 1:18.
95. Alma 16:13.
96. See Enos 1:20.
97. Alma 23:1–2.
98. Helaman 10:8.
99. 3 Nephi 11:1–11.
100. McConkie, *Mortal Messiah*, 1:98.

Temples as Spiritual Monuments

101. 1 Corinth. 15:29.
102. JD, 19:229.
103. Olsen, *Logan Temple*, 165.
104. "The Manti Temple," https://www.lds.org/ensign/1978/03/the-manti-temple?lang=eng.
105. "Vernal Utah Temple," http://www.ldschurchtemples.com/vernal/.
106. "Jordan River Utah Temple," http://www.ldschurchtemples.com/jordanriver/.
107. Ibid.

Temple Topper: Angel Moroni

108. Rev. 14:6–7.

Where Prophets and Paupers Rest

109. "Salt Lake City Cemetery History," http://www.slcgov.com/cemetery.
110. As quoted in Ardis E. Parshall, "LDS Response to the Relocation of Joseph's and Hyrum's Graves, 1928," http://www.keepapitchinin.org/2013/08/30/lds-response-to-the-relocation-of-josephs-and-hyrums-graves-1928.

Pioneer Memorial Park

111. Each of these quotes is taken from *Teachings of Presidents of the Church: Brigham Young*.
112. Moses 1:39.
113. "Mother in Heaven," http://eom.byu.edu/index.php/Mother_in_Heaven.
114. "William Clayton: Reminiscences," http://josephsmith.net/article/william-clayton?lang=eng.
115. "The Author of 'Come, Come, Ye Saints' Invented an Odometer," http://www.mormontabernaclechoir.org/articles/come-come-ye-saints.html.

Of Faith and a Fort

116. "Cove Fort Historic Site," https://www.lds.org/locations/cove-fort-historic-site?lang=eng.

117. "Cove Fort Today," https://www.lds.org/ensign/1995/06/cove-fort-today?lang=eng.

Tabernacles and Other Historic Buildings

118. "Deuel Log Home," https://history.lds.org/article/deuel-log-home?lang=eng.
119. "Torrey Log Church & Schoolhouse," http://www.willhiteweb.com/lds_historic_sights/torrey_log_church/schoolhouse_161.htm.
120. "Pine Valley Chapel, Utah" http://www.stgeorgetemplevisitorscenter.info/pv/pvship.html.
121. Ibid.
122. Marlene Bateman Sullivan, "'Friend and Brother': Jacob Hamblin, Man of Peace," https://www.lds.org/ensign/1984/10/friend-and-brother-jacob-hamblin-man-of-peace?lang=eng.
123. Little, *Jacob Hamblin*, 30.
124. "Jacob Hamblin Home," http://www.utah.com/mormon/hamblin_home.htm. See also "The Jacob Hamblin Home," http://www.stgeorgetemplevisitorscenter.info.

All Is Well with Church Welfare

125. "Deseret Industries," http://eom.byu.edu/index.php/Deseret_Industries.

In the Land of Tragedy

126. "Church Issues Apology for Massacre," http://www.deseretnews.com/article/695209108/Church-issues-apology-for-massacre.html?pg=all.
127. Ibid.

Researching and Preserving the Past

128. "Granite Mountain Records Vault," http://www.mormonnewsroom.org/article/granite-mountain-records-vault.
129. President Joseph F. Smith, while reading the epistle of Peter, third and fourth chapters, was given a marvelous vision of the spirits of the dead and the work of salvation performed for them. See D&C 138.

BIBLIOGRAPHY

Allen, James B. "William Clayton and the Records of Church History." https://rsc.byu.edu/archived/preserving-history-latter-day-saints/4-william-clayton-and-records-church-history-0.

Anderson, Gary N. *Get to Know: Logan's Historic Main Street—A 45 Minute Self-Guided Walking Tour.* Pamphlet. Cache Valley Visitors Bureau.

Bagley, Will. *Blood of the Prophets: Brigham Young and the Massacre at Mountain Meadows.* Norman: University of Oklahoma Press, 2002.

Box Elder Tabernacle. http://www.mormonwiki.com/Box_Elder_Tabernacle.

"Brigham Young's Forest Farmhouse." Markers and Monuments Database, Utah Division of State History. http://heritage.utah.gov/apps/history/markers/detailed_results.php?markerid=2590.

Cannon, Elaine Anderson. "Mother in Heaven." Harold B. Lee Library, BYU. http://eom.byu.edu/index.php/Mother_in_Heaven.

Crowther, Duane S. *Born to Save Mankind: New Insights on Events Surrounding the Birth of Christ.* Bountiful, UT: Horizon Publishers, 2002.

"Deuel Log Home: Living History Program." January 24, 2013. https://history.lds.org/article/deuel-log-home?lang=eng.

"Facts About Utah's Great Salt Lake." http://www.mineralresourcesint.com/facts-about-utah-s-great-salt-lake.

Falk, Aaron. "Temple Square Ranks 16th in Visitors." *Deseret News*, March 12, 2009. http://www.deseretnews.com/article/705290247/Temple-Square-ranks-16th-in-visitors.html?pg=all.

Bibliography

Halleran, Kevin. "Wasatch Mountains." Utah History Encyclopedia, Utah History to Go. http://historytogo.utah.gov/utah_chapters/the_land/wasatchmountains.html.

Heinerman, Joseph. *Temple Manifestations: Heavenly Manifestations in Temples Built by The Church of Jesus Christ of Latter-day Saints, 1836–1930*. Salt Lake City, UT: Joseph Lyons and Associates Inc., 1974.

Hickman, Martin B. "Succession in the Presidency." Harold B. Lee Library, BYU. http://eom.byu.edu/index.php/Succession_in_the_Presidency.

"History of the Organs." Mormon Tabernacle Choir. http://www.mormontabernaclechoir.org/about/organs/history?lang=eng.

Holland, Jeffrey R. "Be Not Afraid, Only Believe." February 16, 2015. https://www.lds.org/broadcasts/article/evening-with-a-general-authority/2015/02/helping-with-the-real-issues?lang=eng.

Hymns of The Church of Jesus Christ of Latter-day Saints. Salt Lake City, UT: The Church of Jesus Christ of Latter-day Saints, 1985.

Journal of Discourses. 26 vols. Liverpool, UK: F.D. Richards & Sons, 1851–1886.

Little, James A. *Jacob Hamblin: A Narrative of His Personal Experience, as a Frontiersman, Missionary to the Indians, and Explorer*. Salt Lake City: Deseret News, 1909.

Madsen, Susan Arrington. "Lorenzo Snow and the Sacred Vision." *Friend*, August 1993, https://www.lds.org/friend/1993/08/lorenzo-snow-and-the-sacred-vision?lang=eng.

Madsen, Truman G. *The Prophet Joseph Smith*. Salt Lake City, UT: Bookcraft, 1989.

McConkie, Bruce R. *The Millennial Messiah: The Second Coming of the Son of Man*. Salt Lake City: Deseret Book, 1982.

———. *The Mortal Messiah: From Bethlehem to Cavalry*. Vol. 1. Salt Lake City, UT: Deseret Book, 1979.

Monson-Burton, Marianne. *Celebrating Passover: A Guide to Understanding the Jewish Passover for Latter-Day Saints*. Bountiful, UT: Horizon Publishers, 2004.

Mormon History and Heritage. http://www.utah.com/mormon/.

Mormon Tabernacle Choir. http://www.mormontabernaclechoir.org/articles/come-come-ye-saints.html.

Olsen, Nolan P. *Logan Temple: The First 100 Years*. Providence, UT: Keith W. Watkins and Sons, 1992.

Orton, Chad M., and William W. Slaughter. *40 Ways to Look at Brigham Young: A New Approach to a Remarkable Man*. Salt Lake City, UT: Deseret Book, 2008.

Bibliography

Parshall, Ardis E. "LDS Response to the Relocation of Joseph's and Hyrum's Grave, 1928." The Keepapitchinin, August 30, 2013. http://www.keepapitchinin.org/2013/08/30/lds-response-to-the-relocation-of-josephs-and-hyrums-graves-1928/.

Petersen, Sarah. "20 Little-Known Facts About the Mormon Angel Moroni Statue." *Deseret News*. http://www.deseretnews.com/top/2075/12/Which-direction-does-the-statue-usually-face-20-little-known-facts-about-the-Mormon-Angel-Moroni.html.

"Pine Valley Chapel." St. George Temple Visitors Center. http://www.stgeorgetemplevisitorscenter.info/pinevalley.html

Saddler, Richard W. "Miracle of the Seagulls." http://eom.byu.edu/index.php/Seagulls,_Miracle_of.

"Salt Lake City Cemetery History." http://www.slcgov.com/cemetery.

Smith, Joseph, translator. *Book of Mormon: Another Testament of Jesus Christ*. Salt Lake City, UT: The Church of Jesus Christ of Latter-day Saints, 1981.

———. *History of the Church*. 7 vols. Salt Lake City, UT: Deseret Book, 1980.

Smith, Joseph Fielding, comp. *Teachings of the Prophet Joseph Smith*. Salt Lake City, UT: Deseret Book, 1976.

"The Story of the Relief Society Building." https://history.lds.org/exhibit/relief-society-building?lang=eng#room-2.

Talmage, James E. *The House of the Lord*. Salt Lake City, UT: Deseret Book, 1978.

Teachings of Presidents of the Church: Brigham Young. Salt Lake City, UT: The Church of Jesus Christ of Latter-day Saints, 1995.

Teachings of Presidents of the Church: Joseph Smith. Salt Lake City, UT: The Church of Jesus Christ of Latter-day Saints, 2007.

Temples of The Church of Jesus Christ of Latter-day Saints. http://www.ldschurchtemples.com.

"10 Inspiring Quotes That Link Mormon Pioneers to the Moderns Saints." http://www.deseretnews.com/top/1674/5/-10-inspiring-quotes-that-link-Mormon-pioneers-to-modern-saints.html.

Utah.com.

Visitor Guide: Cove Fort Historic Site. http://www.covefort.com/.

Walch, Tad. "LDS Church History Museum to Close for Yearlong Renovation, New Emphasis." *Deseret News*, September 24, 2014.

"We All Share Pioneer Legacy." https://www.lds.org/prophets-and-apostles/unto-all-the-world/we-all-share-pioneer-legacy?lang=eng.

Weeks, Andy. *Haunted Utah: Ghosts and Strange Phenomena of the Beehive State*. Stackpole Books: Mechanicsburg, PA, 2012.

Bibliography

———. *Spiritual Temples: Heavenly Experiences in the Houses of God*. Bloomington, IN: iUniverse, 2008.

———. "Thrift Store Helps Job Seekers Bounce Back." *Times-News*, July 9, 2011. http://magicvalley.com/lifestyles/faith-and-values/thrift-store-helps-job-seekers-bounce-back/article_9606c4ca-6eec-5485-9932-d422f5cdb87f.html.

INDEX

A

Americas 37, 65, 84, 93, 107, 108
Andrus, Hiram L. 60
Angell, Truman O. 78
apostles 29, 30, 31, 32, 36, 43, 65, 67, 68, 72, 75, 159
Assembly Hall 69, 70

B

Bagley, Pat 145
Ballard, M Russell 47
baptism 41, 71, 96, 97, 127, 156
baptism for the dead 71
Beehive House 78
Book of Mormon 12, 18, 30, 37, 38, 40, 41, 42, 54, 65, 77, 93, 94, 95, 100, 102, 107, 108, 159
Box Elder Tabernacle 128
Bryce Canyon 24, 131
burial grounds 54, 110

C

Call, Anson 50, 52
Cannon, George Q. 139
Cannon, Michael C. 137
Christ 30, 31, 32, 36, 37, 40, 41, 44, 64, 68, 71, 72, 82, 83, 84, 92, 94, 95, 96, 107, 108, 109, 115, 119, 156, 159, 160
Christus 64
Church Administration Building 74
Church Distribution Centers 141
Church History Museum 154
Church Office Building 72
Clawson, Alice Young 119
Clayton, William 121, 123, 124
Conference Center 67, 68, 74, 75, 76
copper mines 24
Cove Fort 126
Crowther, Duane S. 92
Cumorah 40, 100

INDEX

D

Deseret Book 140
Deseret Industries 136, 137
Deseret News 57, 63, 70, 77, 114, 138, 139, 141, 146
Deuel Log Home 130
Dinosaur National Monument 24
Doctrine and Covenants 30
Dome of the Rock 90

E

Emigration Canyon 49
Eyring, Henry B. 146, 147

F

Family History and Genealogy Center 127
Family History Center 154
First Presidency 72, 74, 82, 103, 120, 136, 137
First Vision 36, 102

G

General Assembly of the State of Deseret 110
ghosts 59
God 11, 12, 29, 30, 31, 32, 34, 35, 36, 37, 38, 39, 40, 41, 43, 44, 45, 46, 52, 54, 62, 64, 71, 82, 83, 84, 85, 88, 89, 90, 91, 93, 94, 97, 107, 108, 118, 119, 120, 131, 133, 135, 138, 159, 160
gospel 29, 30, 31, 32, 34, 36, 44, 45, 66, 71, 72, 74, 83, 96, 107, 108, 109, 131, 156

Granite Mountain Records Vault 155
Great Salt Lake 11, 18, 21, 22, 49, 52, 78, 110

H

Hamblin, Jacob 132, 133, 134
Haun's Mill 146
Heavenly Mother 120
Herod 91, 92, 93
Hinckley, Gordon B. 76, 102, 111, 125, 126, 147
Holland, Jeffrey R. 44, 45
Holy Bible 12, 29, 37, 40, 64, 108
Holy Ghost 31, 41, 119, 159
Holy of Holies 89, 91
Hunter, Howard W. 111

J

James 34, 35, 43, 72, 87, 123
Jesus 18, 30, 31, 32, 37, 40, 42, 43, 64, 68, 71, 82, 83, 84, 87, 92, 93, 94, 95, 96, 108, 109, 115, 119, 159
John 31, 43, 72, 87, 92, 97, 107, 109
Johnson, B.F. 61
Jordan River Temple 103
journal 98, 123, 124
journalism 138

K

Kimball, Sarah Granger 79
Kimball, Spencer W. 103, 111

INDEX

L

Lake Bonneville 21
Lamanites 94, 107
Latter-day Saints 11, 12, 17, 18, 19, 29, 30, 40, 44, 50, 52, 54, 61, 64, 67, 68, 70, 75, 76, 77, 80, 83, 84, 107, 110, 115, 121, 123, 124, 125, 126, 129, 135, 136, 137, 138, 139, 141, 147, 156, 159
Lion House 74, 78
Luther, Martin 32

M

Madsen, Susan Arrington 82
Madsen, Truman G. 34
Mahonri Moriancumer 85
Manti 81, 100, 101
Maxwell, Neal A. 13
McConkie, Bruce R. 84, 85, 88, 89, 90, 93, 95, 111
McKay, David O. 64, 72, 111
Melchizedek Priesthood 72
Millennial Star 69
missionaries 45, 54, 94, 125, 131, 134, 154
Monson-Burton, Marianne 91, 92
Mormonism 29, 43, 46, 68, 77, 115, 117, 119, 121, 123, 131, 137
Mormon Miracle Pageant 102
Mormons 11, 12, 17, 18, 19, 22, 26, 29, 50, 52, 62, 63, 64, 65, 76, 83, 107, 127, 129, 140, 142, 144, 146, 156
Mormon Tabernacle 66, 68, 76
Moroni 37, 38, 39, 41, 100, 107, 109

Moses 17, 30, 34, 45, 52, 85, 87, 88, 89, 90, 91, 92
Mountain Meadows 142, 146, 147
Moyle, Henry B. 111
Music and the Spoken Word 68

N

National Register of Historic Places 77, 129, 132
Nauvoo 30, 79, 111, 114, 115, 123
Nebo 22
Nephites 65, 84, 93, 94, 95, 107, 108
news gathering 139
newspaper 57, 69, 138, 139
New Testament 32, 43, 44, 71, 92

O

Ogden 19, 103, 105
Ohio, Kirtland 66
Old Testament 17, 18, 30, 52
Olympics 19
Oquirrh Mountains 24, 54, 110
ordinances 31, 83, 84, 88, 89, 96, 108, 156, 159
Oregon Trail 142
Orton, Chad M. 45

P

Perry L. Tom 26
Peter 32, 36, 43, 72, 87
Phelps, William W. 139
Pine Valley Chapel 131
Pioneer Memorial Park 116, 120, 124
pioneers 12, 22, 26, 47, 49, 74, 75, 116, 121, 123, 130

INDEX

prayer 29, 34, 37, 41, 56, 72, 91, 93, 103, 133
priesthood 30, 31, 32, 36, 43, 45, 52, 87, 88, 89, 96, 100, 156
Promised Messiah 29, 65
prophecy 18, 43, 50, 108, 159
prophets 29, 30, 32, 36, 41, 66, 67, 68, 75, 84, 89, 95, 100, 108, 109, 110, 115, 159

Q

Quorum of Twelve Apostles 43, 47, 72, 74, 132, 139

R

Red Fleet Reservoir 24
Relief Society Building 78, 79
Richards, Stephen L. 64
Rocky Mountain Prophecy 50
Rocky Mountains 15, 17, 22, 46, 50, 51, 54, 123, 133, 139

S

Salt Lake City Cemetery 110, 115, 124
Salt Lake Temple 66, 71, 72, 74, 78, 80, 81, 105
Satan 39, 98, 99
Savior 29, 36, 38, 42, 64, 65, 71, 82, 87, 92, 93, 108
Sinai 85, 89, 91
Slaughter, William W. 45
Smith, Emma 72
Smith, Hyrum 61, 111
Smith, Joseph 15, 17, 27, 29, 30, 34, 37, 39, 41, 43, 44, 46, 49, 50, 57, 66, 71, 72, 74, 77, 78, 79, 96, 107, 108, 109, 115, 117, 119, 120, 121, 123, 138, 146
Smith, Joseph Fielding 72, 102
Smith, Joseph, Sr. 39
Smith, Mary Fielding 60
Snow, Eliza R. 116, 119, 120, 121
Snow, Lorenzo 82, 101, 119
Solomon 90, 91, 93, 96
Spirit 31, 36, 42, 80, 120, 133
stake conference 102
St. George 26, 57, 81, 97, 129, 131, 133, 134, 146
St. George Temple 97, 129

T

Talmage, James E. 85
Taylor, John 30, 70, 98
temple 18, 31, 65, 69, 78, 79, 80, 82, 83, 84, 88, 89, 90, 91, 92, 93, 94, 95, 96, 97, 99, 101, 102, 103, 105, 141, 156
Temple Square 63, 64, 66, 67, 68, 69, 70, 72, 75, 78, 79, 80
This Is the Place 49, 52, 54, 57
Thorvaldsen, Bertel 64
Times and Seasons 79
Tooele 24, 133
Torrey Log Church/Schoolhouse 130, 131
Tower of Babel 37, 84

U

Uintah Stake 102, 103
Urim and Thummim 38, 40
Ute Indians 23

V

Vernal 24, 102, 103

W

Wallace, George 110
Wallace, Mary B. 110
Wasatch Stake Tabernacle 129
Washington, George 97
Woodruff, Wilford 80, 82, 97, 98, 127, 128
Wycliffe, John 32

Y

Young, Brigham 11, 17, 26, 34, 43, 45, 46, 49, 50, 52, 54, 56, 57, 59, 60, 68, 70, 74, 78, 80, 100, 101, 110, 116, 119, 121, 125, 128, 130, 133, 134, 140, 143, 147
Young, Brigham, Jr. 129
Young, Joseph Angell 119
Young, Mary Ann Angell 119
Young, Mary Van Cott 119

ABOUT THE AUTHOR

 Andy Weeks is an award-winning journalist who has worked for newspapers and other media outlets in Utah and Idaho. His work, both fiction and nonfiction, has appeared in magazines in both the United States and United Kingdom. He is the author of several books, including *Haunted Utah: Ghosts and Strange Phenomena of the Beehive State*.